�켕 U S I N G H I S T O R Y ➛

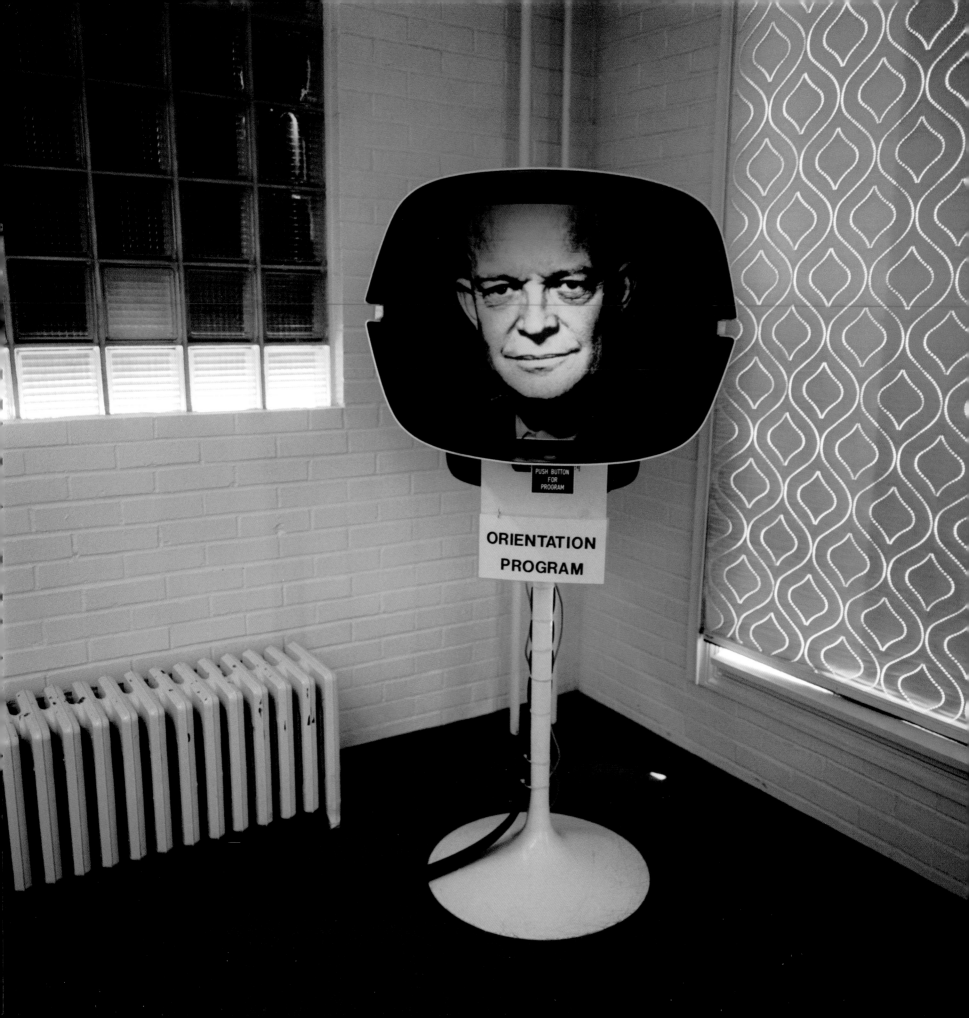

GRETA PRATT

→ USING ←
HISTORY

Essays by Rennard Strickland and Karal Ann Marling

STEIDL

Some years ago, I visited Stickney, South Dakota to photograph their centennial celebration. The week of festivities concluded with a pageant recounting the tale of Stickney's one hundred years of existence. The whole town's population, all 423 of them, arrived to claim a hillside seat on Vernon Peter's farm, the prairie stretching before them as a stage.

The sun lingered close to the horizon as Lewis and Clark walked across the plain searching for the Pacific Ocean. Behind them came women in sunbonnets and calico dresses beating pretend prairie fires with potato sacks, followed by missionaries dressed in black. During the intermission, the master of ceremonies told jokes and imitated Bing Crosby, while "Indians" dressed in homemade burlap costumes, their white faces painted to portray "otherness," gathered in the background.

The second act brought war whoops and galloping horses to signal the demise of Custer, followed by prospectors, gold-sifting pans in hand, and cowboys driving cattle. The grand finale featured a favorite son, who had left Stickney to play in a lounge act in Fargo, returning to play "Great Balls of Fire," on an upright piano. As the crowd went wild, clapping and cheering, a crop duster landed, carrying the surprise guest, a state senator.

Later that night in my hotel room, I wondered how these events expressed history. What would the Native Americans who lived on a reservation outside of Stickney think of this pageant? What would their version of history say about the last one hundred years? I decided to photograph how Americans remember the past, in order to understand what is revealed by the events we choose to celebrate as history.

Initially I went to sites I studied in elementary school: Plymouth Rock, Jamestown, Gettysburg, Mount Vernon, the holy sites of American history. Everywhere I went, I found others exploring the past: retired couples in RVs, and families on vacation stopping at historical markers. I met Civil War buffs reenacting on ancient battlefields, and Vietnam veterans visiting memorials steeped in experience still fresh enough for tears. Everyone was trying to find a way to connect to the past.

I observed historic iconography everywhere and realized that its usage elicits a predictable response, valuable for selling merchandise, constructing identity, and invoking patriotism. I began to understand how the framing of the past evolves, reflecting the belief and ideals of the present.

These photographs are my quest to understand how I, and we, remember history. My intention with these images is to address how the culture and morality of today are reflected in what we commemorate about the past.

Greta Pratt, 2005

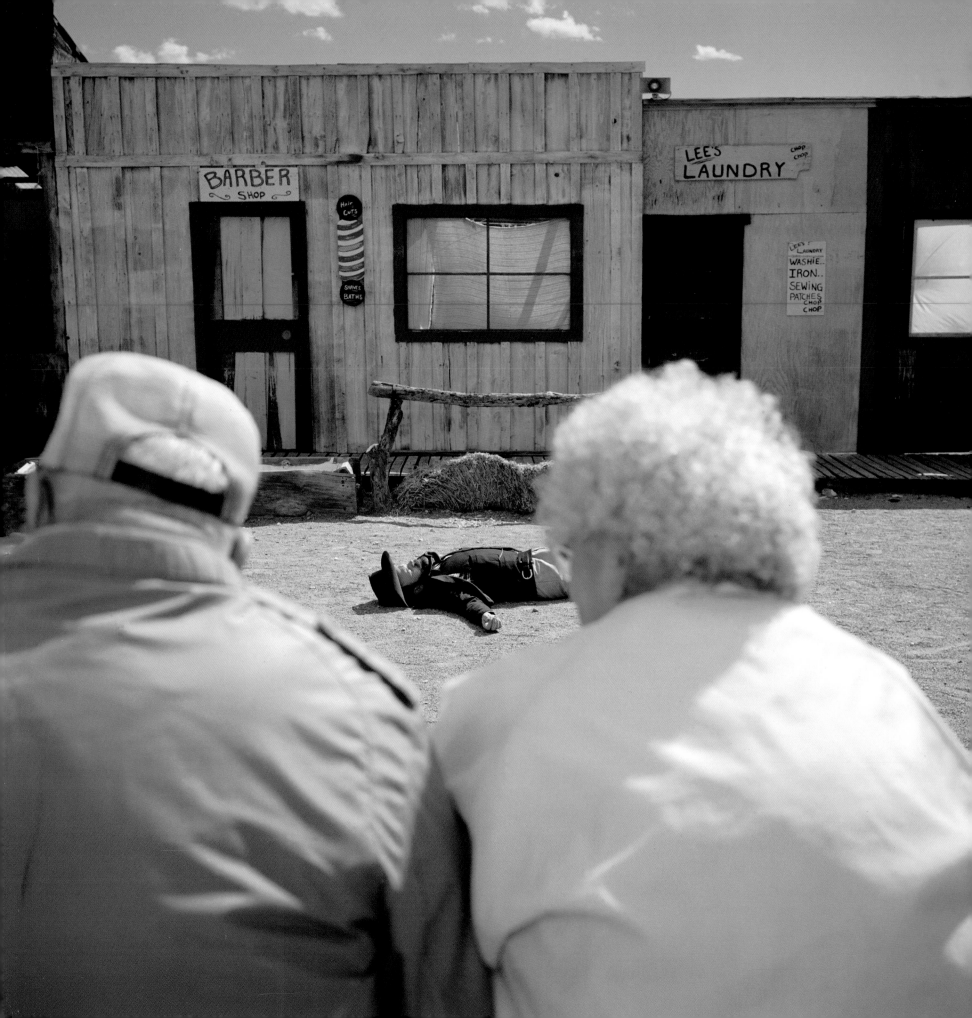

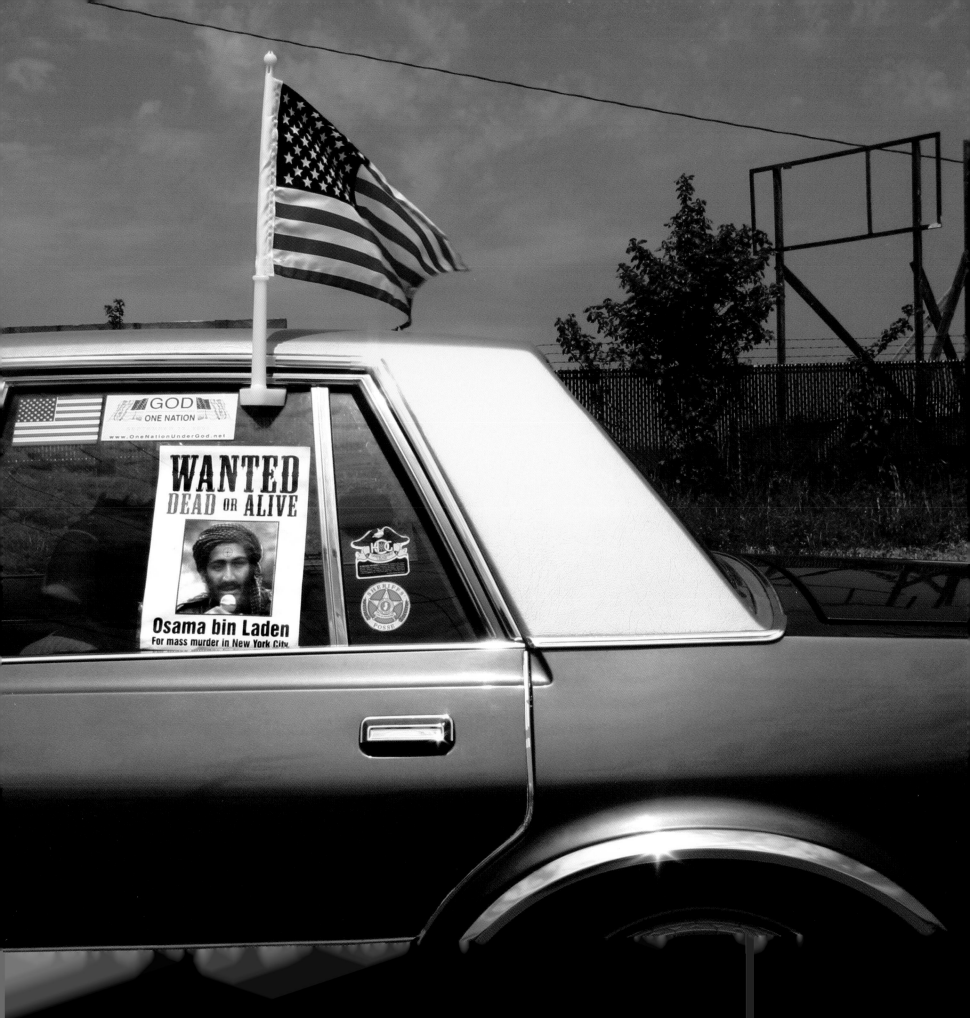

PUBLIC HISTORY, VERNACULAR STORYTELLING, AND THE SEARCH FOR SELF:

Observations on Identity and the Spirit of Place in the American Experience

This book is a collection of photographs about history perceived, about how we look at ourselves and others, about how we recreate and reaffirm the American experience, about how we continue to live with, to rationalize, and to atone for the lingering spirit of place. Decades ago, I began quoting Ralph Waldo Emerson to my legal history students. My favorite Emerson quote is, "There is no history, only biography." I often add that, for most of us, history is not just biography but mostly autobiography. We see history — we reshape and reframe history — in terms of our own experience. And in turn, we use this to build not only our own identity, but the identity of our family, our race, our community, and our class. Thus we define our place as Americans.

Greta Pratt chose *Using History* as the title for this superb collection of photographs of Americans celebrating their lives in the context of their view of history. Pratt is a widely recognized and honored photographer whose works are represented in major museum collections, including the National Museum of American Art and the Museum of Fine Arts, Houston. She has been nominated for a Pulitzer prize, served as photography bureau chief of Reuters International in New York City, and has had photo essays published in major magazines, including *The New York Times Magazine*. An earlier book, *In Search of the Corn Queen* (1994) captures the county fairs of the Midwest where she grew up.

Karal Ann Marling, the distinguished art historian and chronicler of American culture, observed of Pratt's photographic world: "It is make-believe and dress up for grown-ups. Touristic nostalgia for stirring myths and childhood legends, for things that never were. A weekend vacation in the foreign land called history."

Pratt's photographs help create an understanding of a special form of vernacular storytelling, of acting out and dressing up the past. History as we remember it emerges from her photographs. Perhaps it could more correctly be labeled history as we want it to be remembered or, even better, as we re-create and relive it. As the American novelist Willa Cather reminds us, "Memory is better than reality." In a sense, Pratt's cover photograph of the young man with the headless Philadelphia statue speaks for the task of "helping us get our head on straight."

In describing these photographs, Verlyn Klinkenborg, writing in *Mother Jones,* concluded: "What Pratt catches here is not merely anachronism or irony…What you see here is the attempt by ordinary people — nonhistorians, that is — to capture history in a form that makes it locally communally tangible — history as shared terrain…There is an idea in most of these faces, though. The idea is continuity with forebears, with first principles, with a larger conception of the time horizon than everyday life usually affords."

Greta Pratt's photography is not just about the past and reliving former glory. Some of her scenes take place at space centers, around airplanes, and just out on the highways. She poignantly captures the sense of the historic place while throwing light on the present and the future. Among the most touching of this photographer's works of art is a young man dancing on a New Jersey memorial with the twin towers of the World Trade Center standing in the background. Equally moving is a pair of modern soldiers with a costumed revolutionary warrior in the background, a "little patriot" at Williamsburg, and a person of color selling a 9/11 T-shirt in New York City. In yet another photo, the juxtaposition of past and present is repeated in the foreground sculpture of a buffalo against the background Winnebago traveling van. The portrait of a woman in colonial attire clicking a photograph with her disposable camera is an appropriate metaphor for what Pratt has herself sought to do.

In this introductory essay, I ask each reader, all viewers of these photographs, to look back on their own personal history and the retelling and the shaping of it in their life experience. Where and how have we been shaped by this vernacular history? My own earliest personal memories clearly define my identity. My identity as a mixed-blood Osage/Cherokee who is, in the words of Merle Haggard's Vietnam-era song, "An Okie from Muskogee." All of my early remembered experiences could have been the subject of one of Greta Pratt's wonderfully ironic photographs.

My very first public memory is of the rodeo at the Muskogee Free State Fair - - of Plains Indians dancers and calf-roping cowboys. It was apparently not as good an experience for my mother, who remembers that I screamed so much at the throwing of the bulls that she spent more time walking me outside the fence than watching the bulldoggers. The next thing I remember is a World War II war bond rally at the Ritz Theatre in downtown Muskogee, where uniformed soldiers from nearby Camp Gruber and local women of the DAR and UDC, in their colonial and Civil War era costumes, marched across the stage and up and down the aisles. Local civic leaders and politicians, including my own merchant father, spoke of the need for dollars to win the war, and preachers called for God's support in upholding the American cause. This patriotic rally produced the first real thought I can remember: I wondered if preachers in Germany and Japan didn't proclaim that God was on their side, too. Finally, a couple of years after the war, I vividly recall the 1948 celebration of "The Five Tribes Indian Centennial." For this pageant, my Cherokee father turned thespian and square-danced when the Indian people arrived at the end of the "trail of tears." This celebration embodied all of the happy "civilized Indian" settlement myths that were so central to mid-century eastern Oklahoma tribal identity.

No doubt my own very different personal experience as a mixed-blood out in Oklahoma drew me to Greta Pratt's grandly absurd photograph "Thanksgiving at the Rainbow Room, New York, New York." What appear to be three generations of a prosperous Yankee family dressed in their finest WASP costumes are seated on a pile of pumpkins.

They are wearing crepe paper and feathered Indian war bonnets, smiling as if they just bought Manhattan for a string of beads.

The Rainbow Room celebrants provides an interesting identity clash with a Thanksgiving tale my colleague Jack Gregory and I recorded almost four decades ago. This is a personal Thanksgiving story remembered by a Cherokee from his grade school days.

We did a little play called "The First Thanksgiving." They choose up the parts and I remember, sure enough, the teacher chose me to be one of the Indians. I made a paper tomahawk and put a paper beaded thing around my head and came in and talked like "Me heap big Indian, I want to help out starving pilgrims." I brought in a cardboard turkey. The white kids played the pilgrims. I remember my grandfather came in and he would laugh at the wrong places and he would speak in Cherokee real loud. When he saw me come out with my tomahawk, he got so excited when I was thinking about tomahawking the pilgrim. My grandfather wanted me to actually do it. He told me he wished I'd gone ahead. If we had killed the first pilgrims we wouldn't have any troubles now.

Native American imitation, re-creation, and reinvention of the white man is not new. Indian policy makers in the nineteenth century spoke of the task of "Americanizing the American Indian." Photographs from Indian schools often show the "before and after" of Native children shorn of their braids and now in military school uniforms. George Catlin, the frontier artist, painted the Native diplomat Pigeon Egg transformed into a dandy in top hat after a visit to the national capitol. Native artists turned the table with argulite carvings of white ship captains; plains warrior painters imprisoned in Florida did similar satire. As recently as the end of the twentieth century, teachers at a Bureau of Indian Affairs school created a Geronimo Santa Claus. The Hopi artist Fred Kabotie's murals in the Bright Angel Lodge bar at the Grand Canyon are a great satirical send-up of white tourists.

Toward the end of Thomas Wolfe's monumental novel *Look Homeward Angel,* the hero Eugene confronts the ghost of his brother Ben. On a quest to find himself and his place in the world, he asks Ben's spirit for help in finding the answer to his life. Ben replies, "You are your world." The ghost's wisdom was that each of us creates ourselves and makes the world in which we choose to live. Greta Pratt's photographs show the worlds various American people have made and the process by which they make them. Her photographs are of many worlds. Some of these are historically valid, others totally false. As Americans, we have created them all in our minds and in our celebration.

Pageants, reenactments, parades, and costumed figures are not new. Indeed, we have historic photographs and paintings of earlier Americans in the same creation process. For example, the Tennessee and Texas hero Sam

Houston had himself painted as a Roman senator standing amid classic ruins. A photograph of a gathering of the "robber barons" of the Gilded Age shows them in laurel wreaths and togas seated at an elaborate Victorian banquet. The 1876 American centennial featured many historic reenactments and tableaus as does the twenty-first-century Lewis and Clark celebration. One of the great scenes in Meredith Wilson's *Music Man* is the Fourth of July recreation of pictorial and historic moments — prairie tableaus — by a group of local citizens directed by the mayor's wife.

Looking at faded pictures and re-created costumes in such an historic context, one understands the truth of Thomas Carlisle's assertion that "dress is the most rhetorical of all statements." In some ways, the process is like the ancient shaman who wears the feathers of the raven, skin of the tiger, or the head of a wolf to possess the traits of the animal. In many of Pratt's portraits, ordinary folks appear as famous figures or with them. For example, we have an autograph-signing General George Armstrong Custer, paper cut-out heads of George Washington hanging in a grade school classroom, and a gathering of nine Abraham Lincoln impersonators. No doubt, the smiling Custer, here photographed, is a long distance from the cavalry leader who destroyed a peaceful Indian village at the Battle of the Washita. One wonders about meaning and quest when John Water's cross-dressing film star Divine recalls as a teenager dressing up as Martha Washington. I often think of these costume transformations during the "interview season" when students in my classes put on their lawyer suits (both male and female) to become the candidates that law firms would want to hire.

Europeans, especially when they come to the United States for the first time, are amazed at not only the vastness of the continent but the almost limitless diversity of the citizens. There is no single American historical experience. Even the Pratt photographs are just a small part of the story. The world of Hispanics and Asians, for example, are not here represented. However, many of the national icons familiar and celebrated by all Americans shine forth in her photographs. The Statue of Liberty, a deliberately created symbol, looms large with schoolchildren dressed as immigrants standing before her on Ellis Island or as a popcorn-eating spectator at Madison Square Garden.

Unfortunately, this is not just the stuff of costume galas. Reenactment and storytelling can have a dark, difficult, and disturbing side. Too often they seem to give the truth to an historic lie. It is in many ways like the old-time southern minstrel show or a Buffalo Bill Wild West Circus brought with all their stereotypes into the twentieth and twenty-first centuries. We see the disintegrating impact of this in the controversy over the use of blackface in the Mummers Parade in Philadelphia, or the Native American protests at the Columbus Day celebration in Denver. All of this is just beneath the surface in Pratt's photo of a *Texas* Juneteenth Pageant and the African American waiter arriving to serve a "Confederate celebration" in Richmond, or the photographs of *the Black Panthers*, or the Ku Klux

Klan in a Baltimore Black History wax museum. It is echoed in activist Jane Fonda (unfortunately, not photographed here) wearing an Indian beaded headband engaged in the great masturbatory gesture that is the Atlanta Braves "tomahawk chop." A number of "Mardi Gras Krewes" dress as Indians and this, in turn, has resulted in hostile confrontations. Perhaps the best known of these is the Florida Krewe of Chasco in the Chasco Fiesta in New Port Richey, Florida. This pageant, which was ended two years ago, was described by a local critic as follows:

> We have succeeded in ending a pageant after 82 years of annual performances in which we are told Spaniards taught Florida Calusa Indians how to plant corn and squash, in which children dressed as generic Indians made stabbing motions onto the chests of children dressed as captured Spaniards sacrificed to a fictitious god, in which Indians are called savages, heathens, and pagans, and whose happy ending is when the Indians spare two white children and make them their king and queen while converting to Christianity. Also ended are activities in the Children's Indian Village such as Pick the Pocket of the Drunken Injun.

And what of the future? How can the spirit of place, the sense of self, and American Identity emerge into a creative force with an energy that acknowledges the differences in our historic experience, and especially our remembering and retelling our story? This will require more than dressing up as Lincoln or signing off as George Armstrong Custer or even wearing pioneer and Indian costumes to the grocery store. It will require a kind of hard-hitting acknowledgment, even perhaps a public atonement, of the history we have tried so long to forget. It is at this point that we must call upon our basic shared values, our sense of fair play, right of free speech, and desire to create a history that is true but also acknowledges the values of the diverse American experience. It is not, as Pratt's art suggests, going to be an easy task.

The novelist D.H. Lawrence reminded us of this challenge when he wrote of the history of the cursed land:

> America hurts, because [the land] has a powerful disintegrative influence upon the white psyche. It is full of griming, unappeased and aboriginal demons, [and] ghosts, and it…is tense with latent violence and resistance.… Yet one day the demons of America must be placated, the ghosts must be appeased, the spirit of the place atoned for.

Rennard Strickland

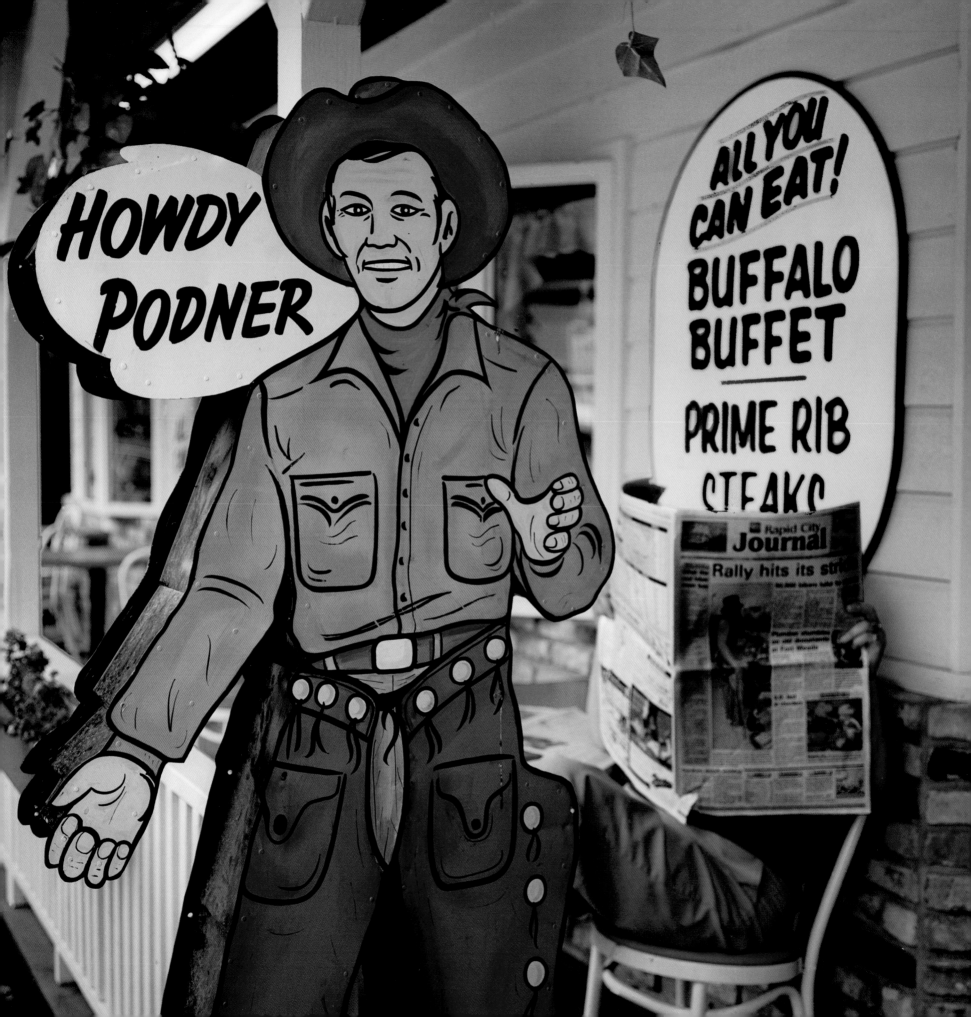

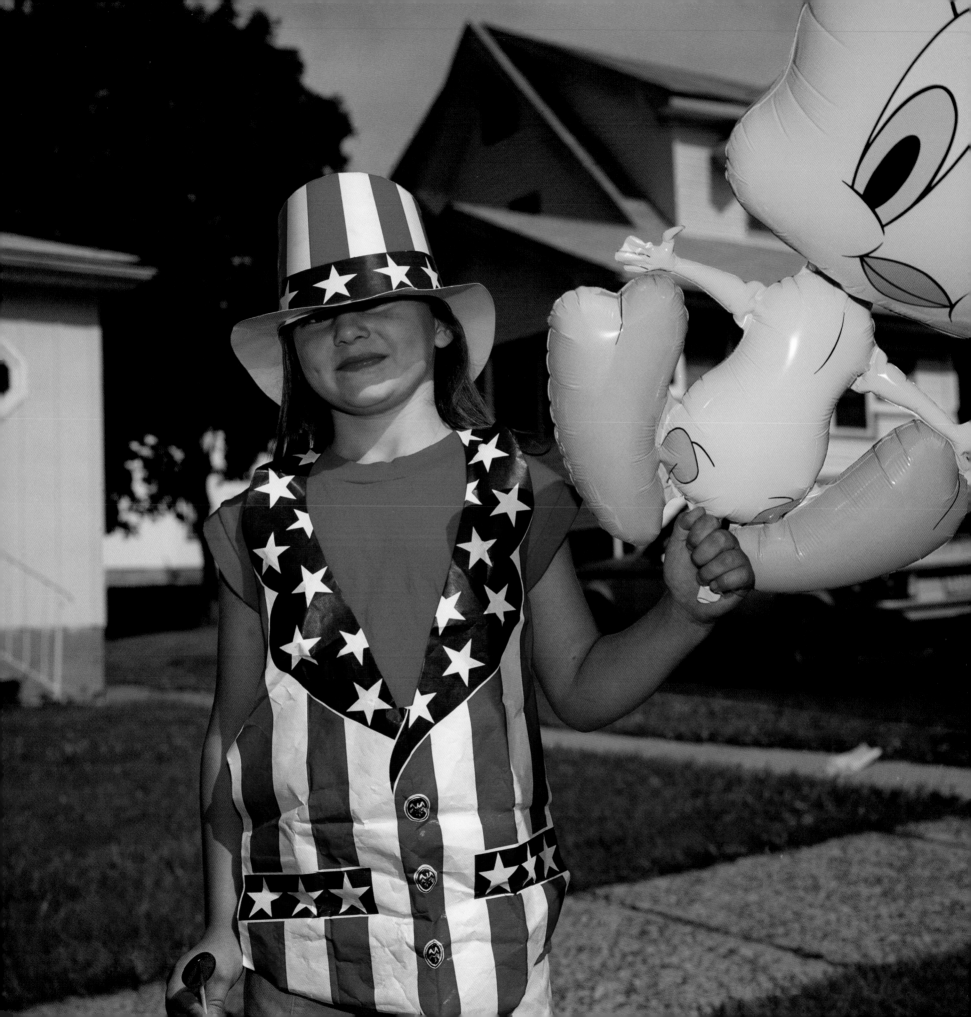

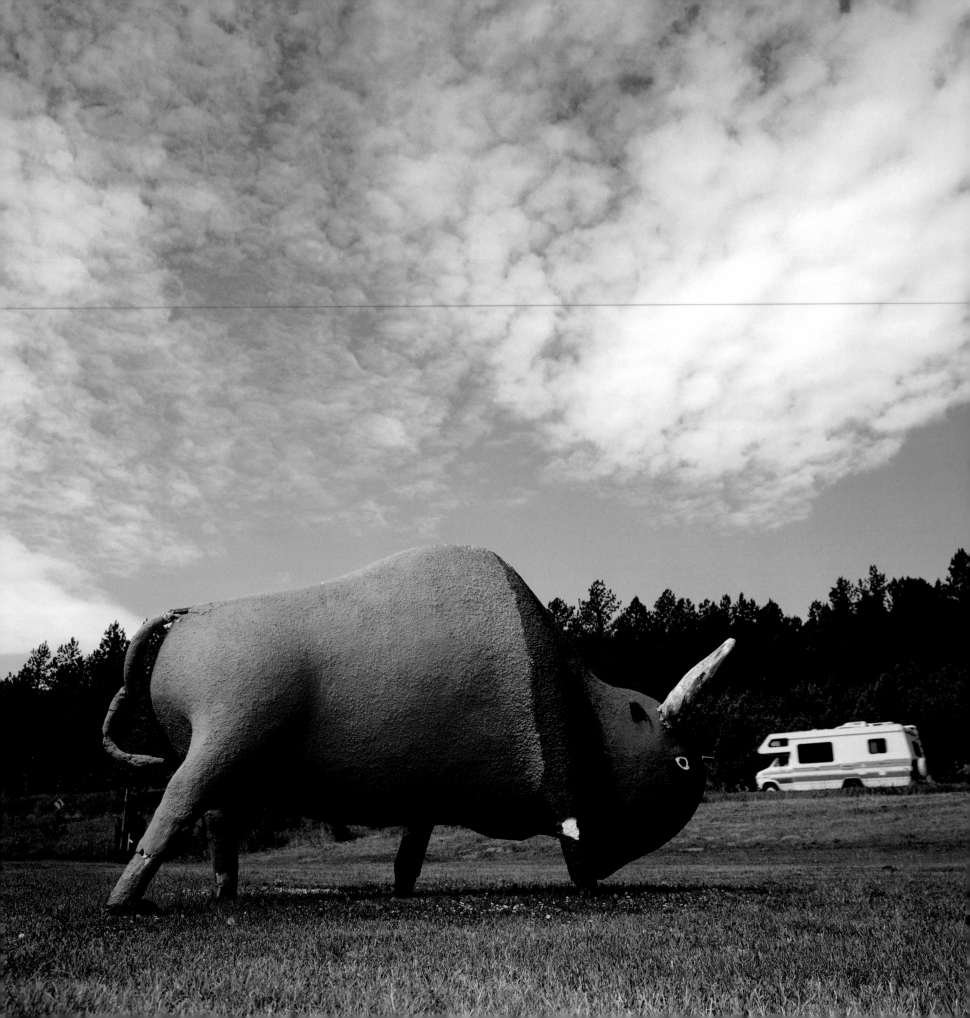

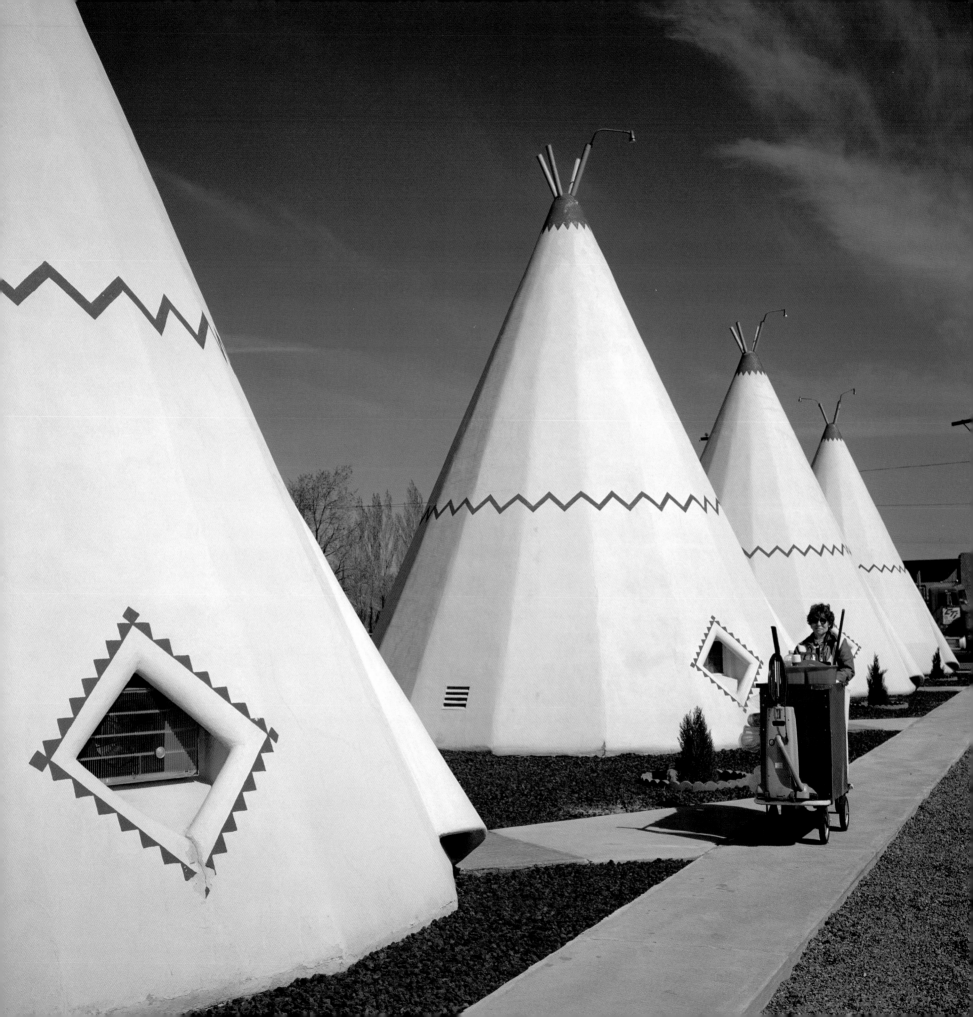

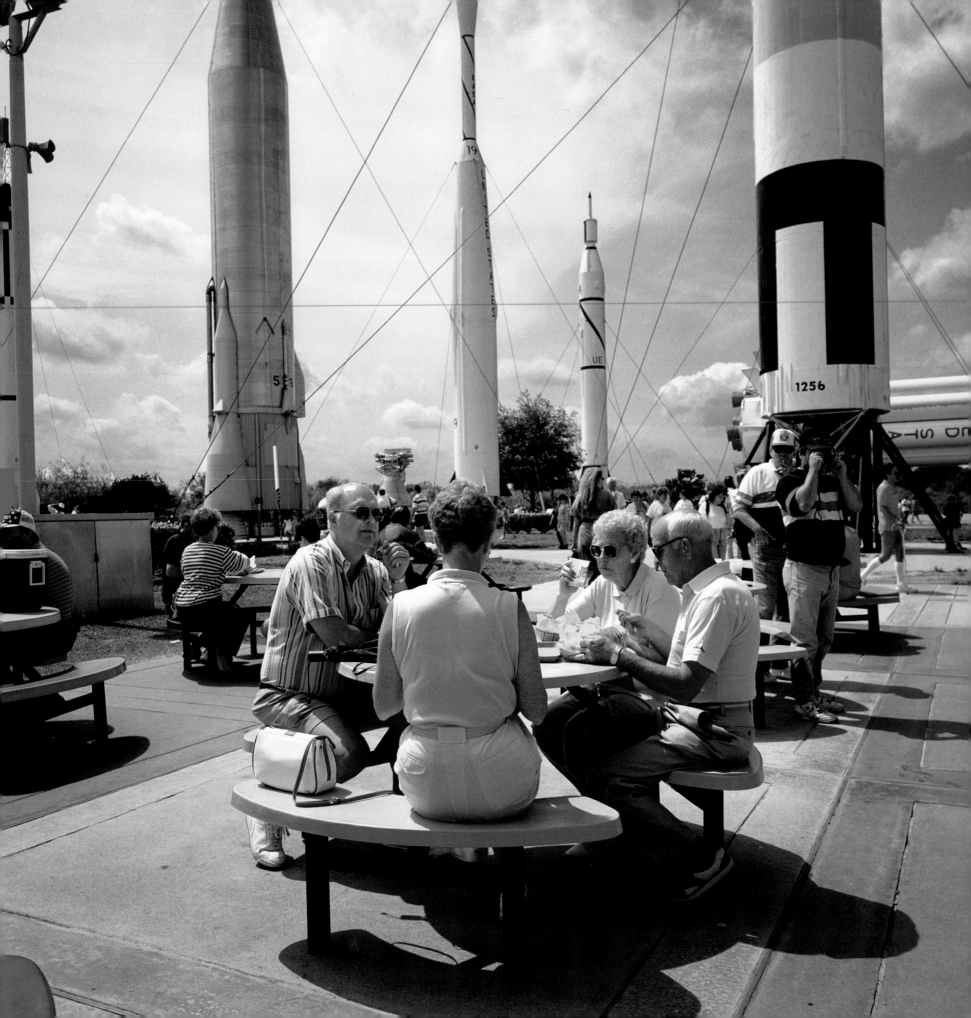

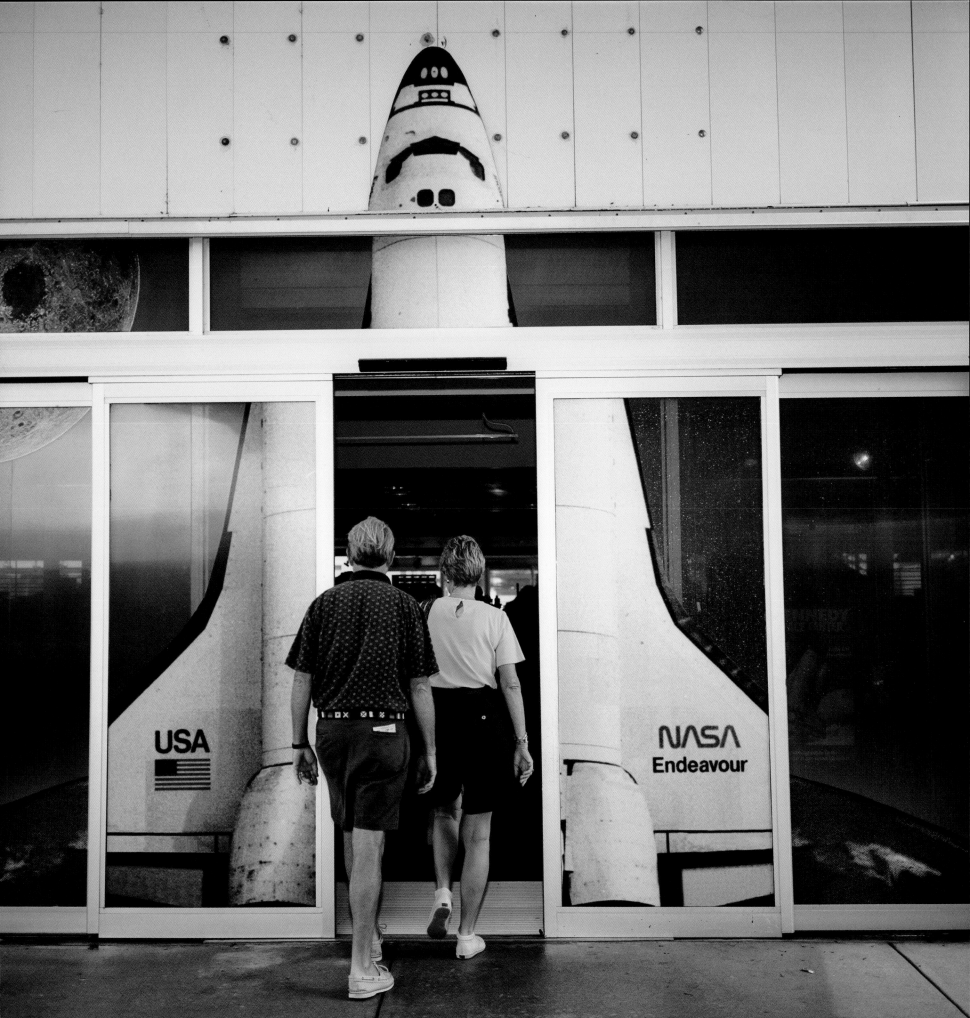

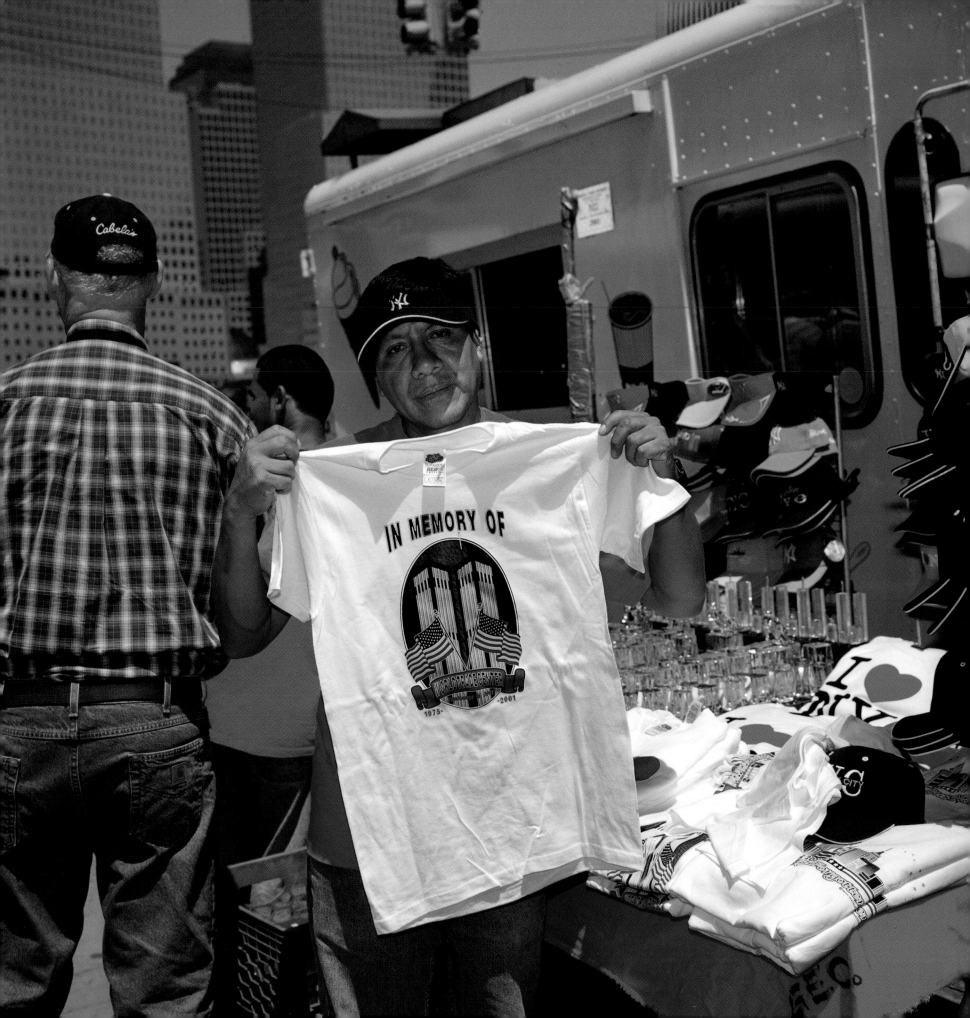

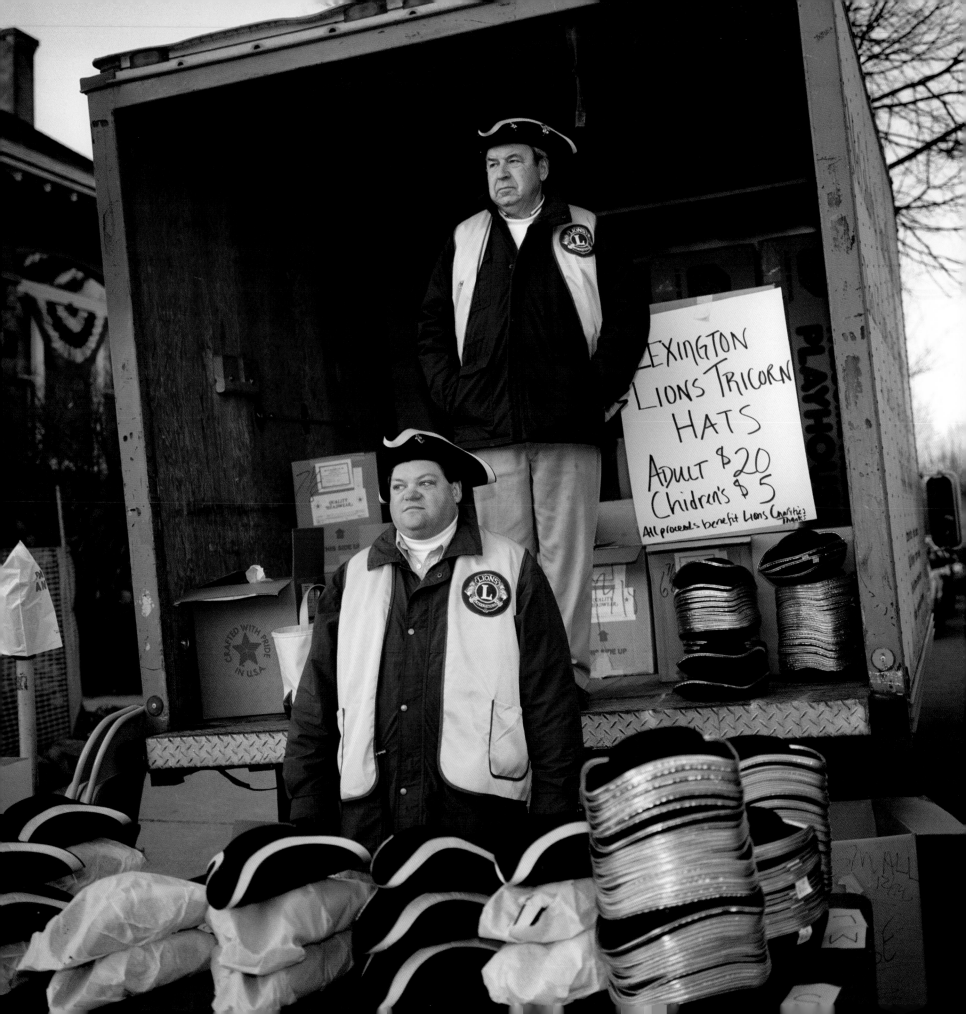

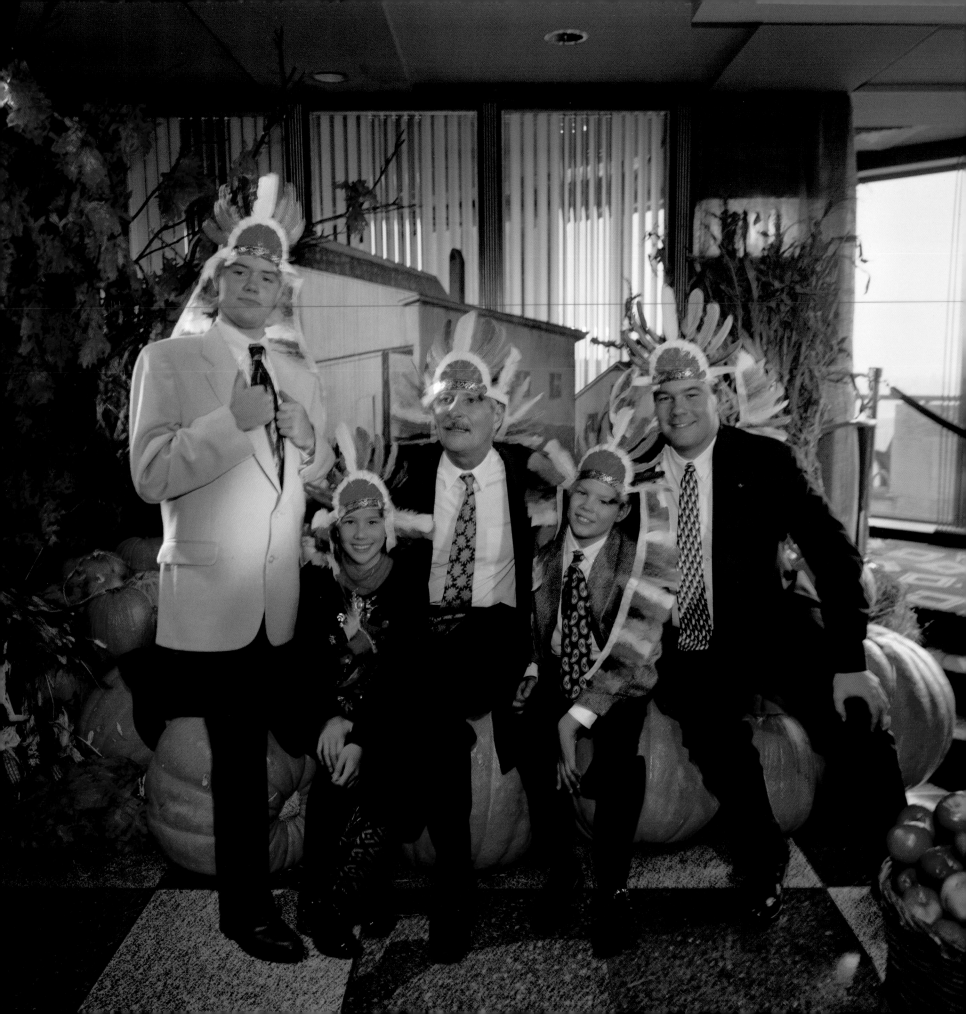

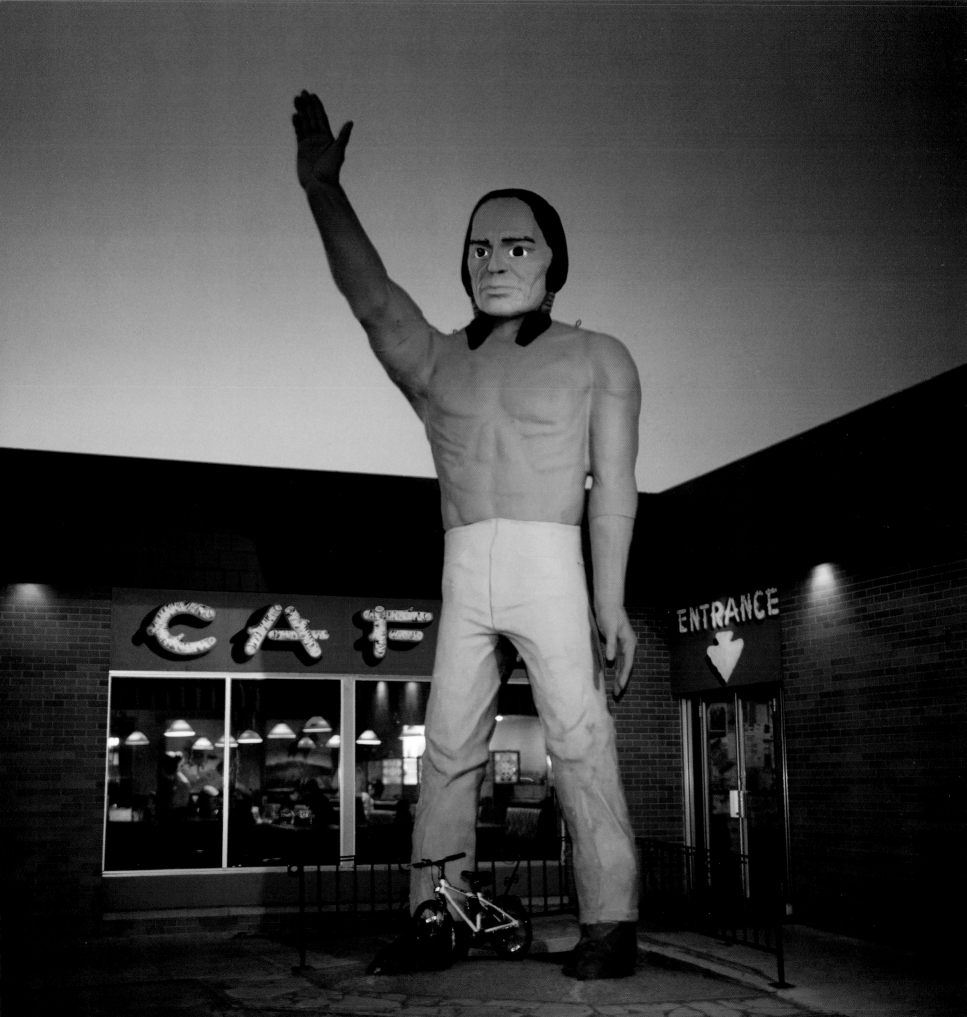

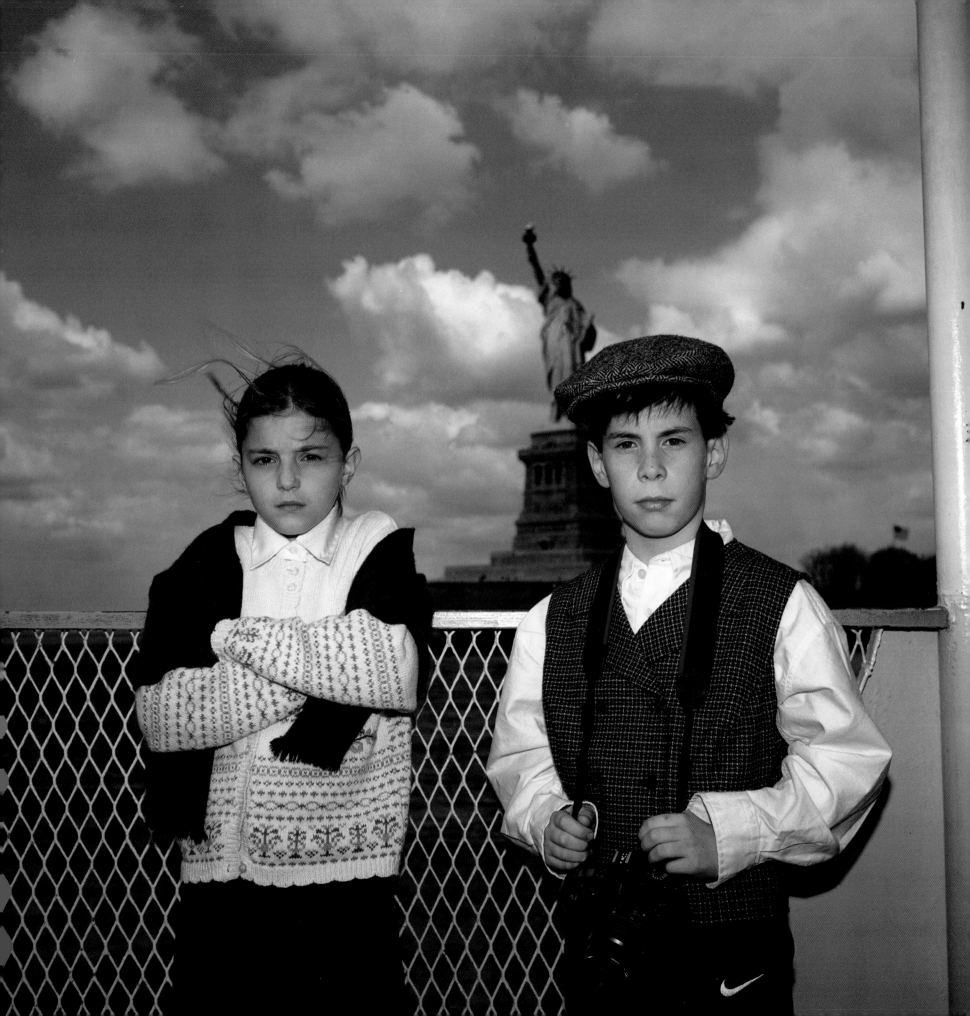

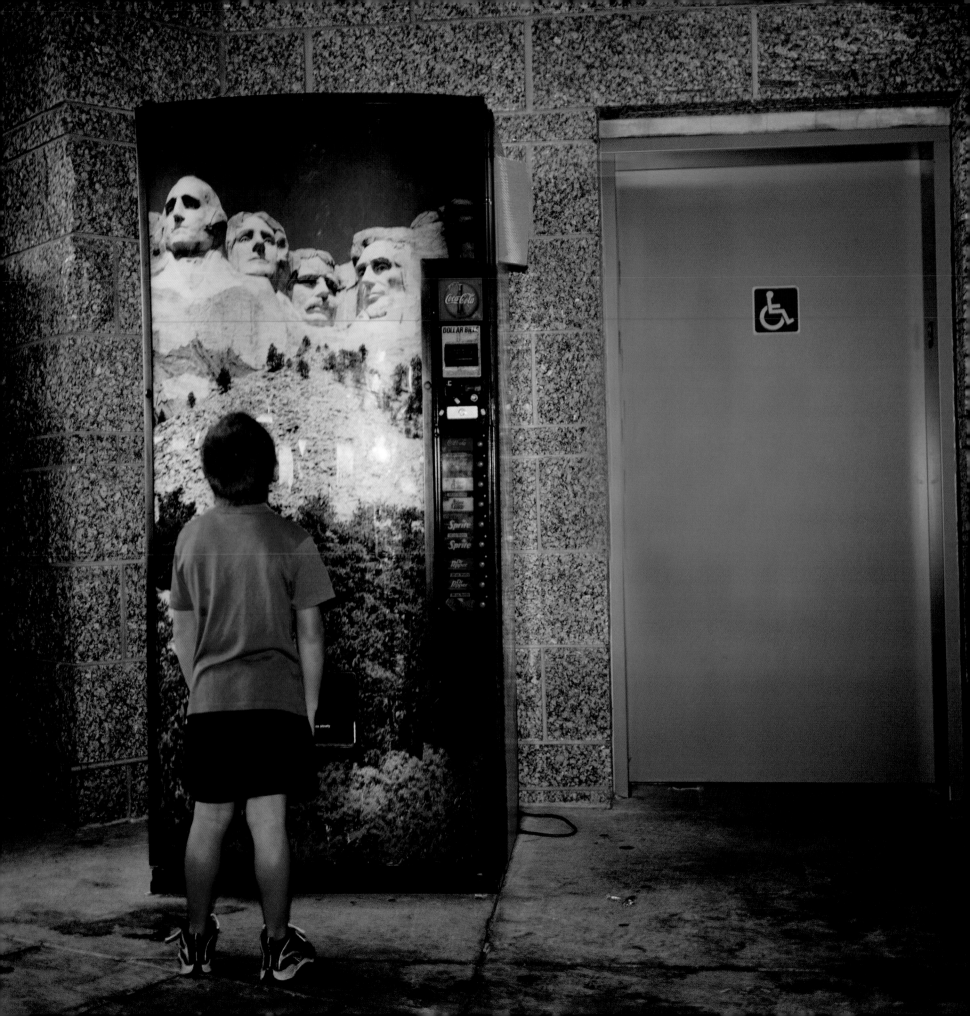

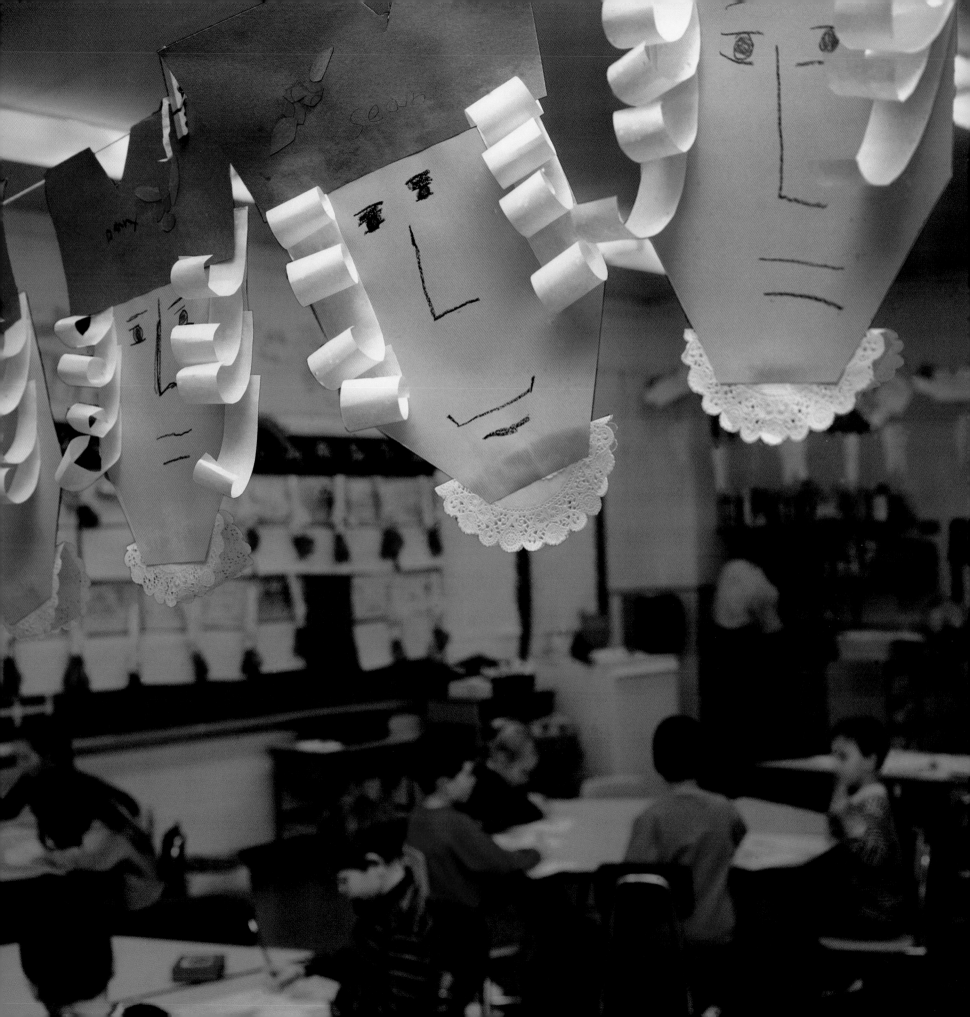

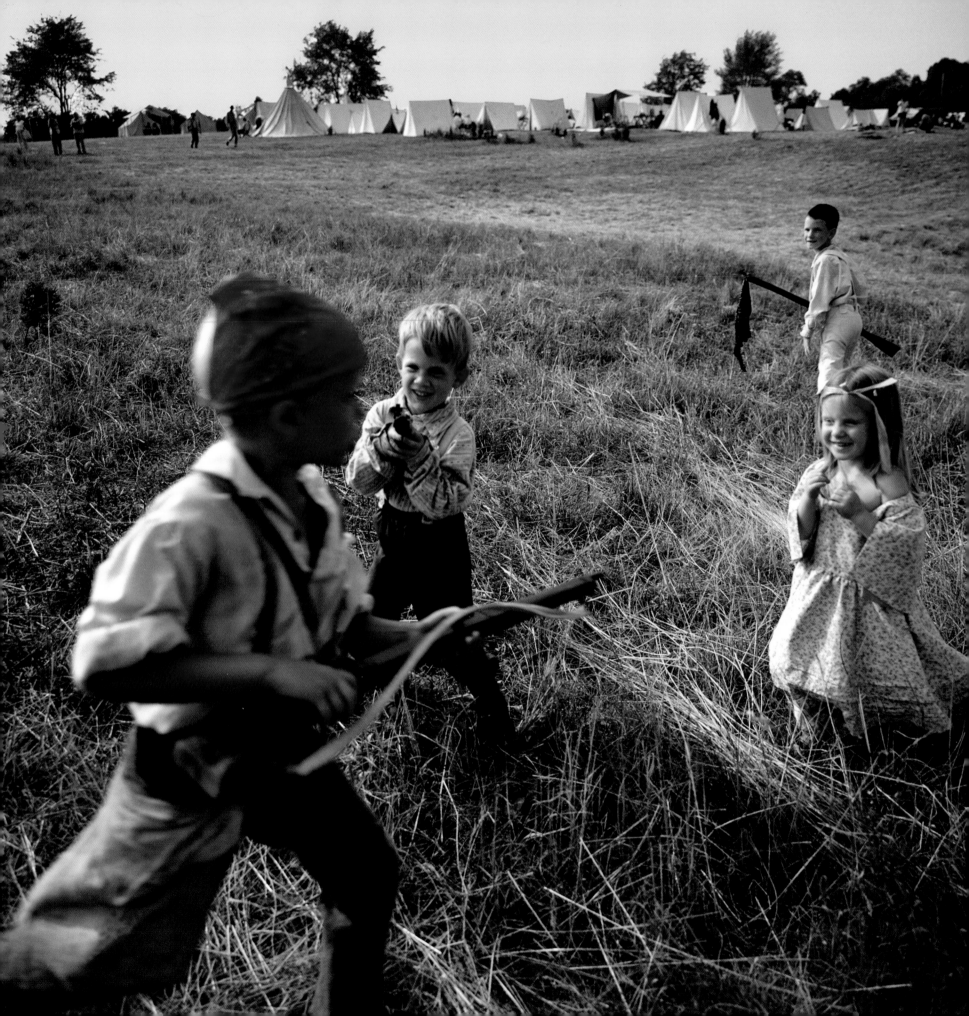

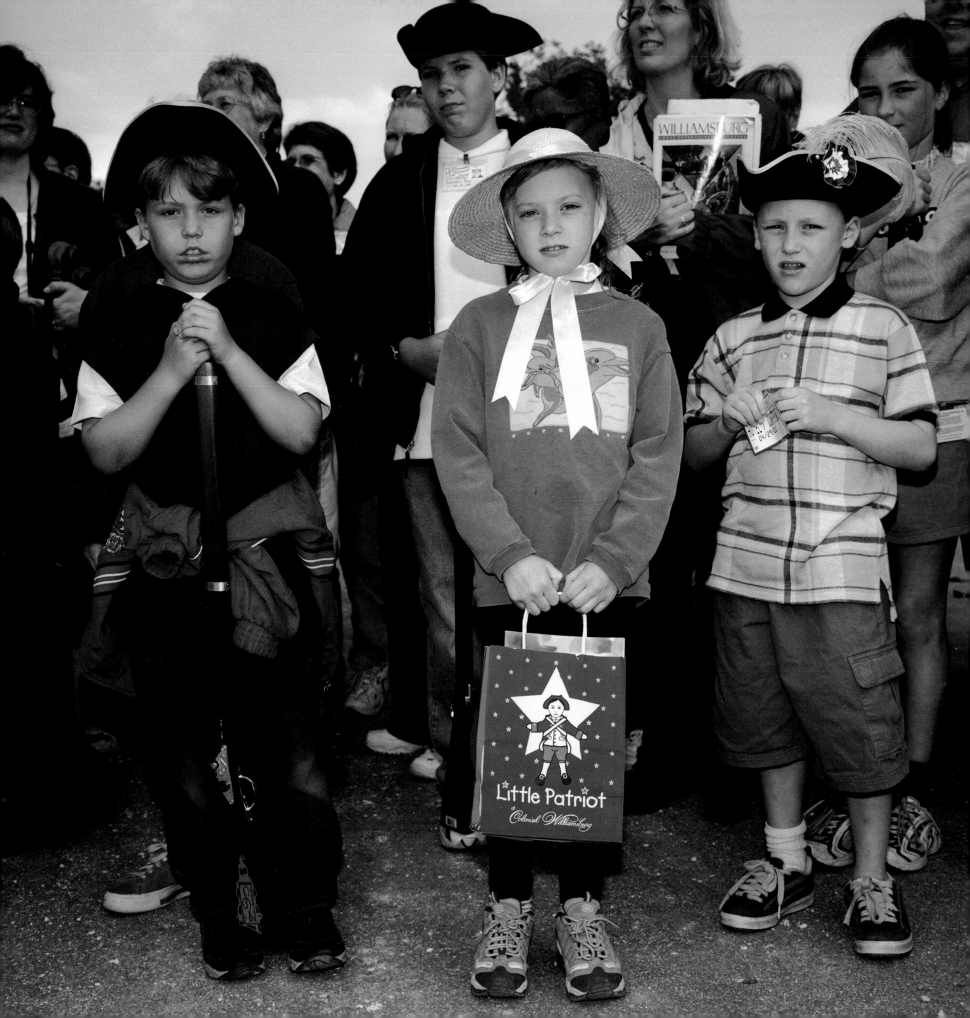

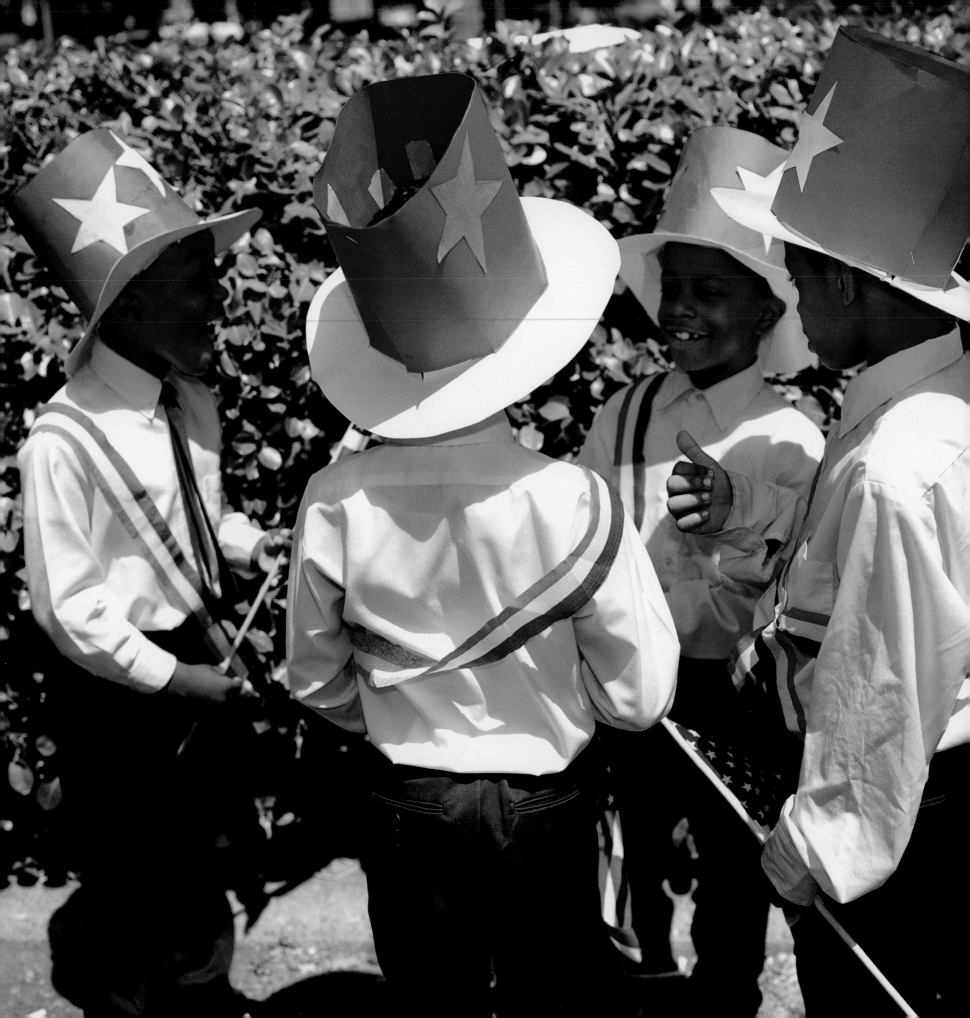

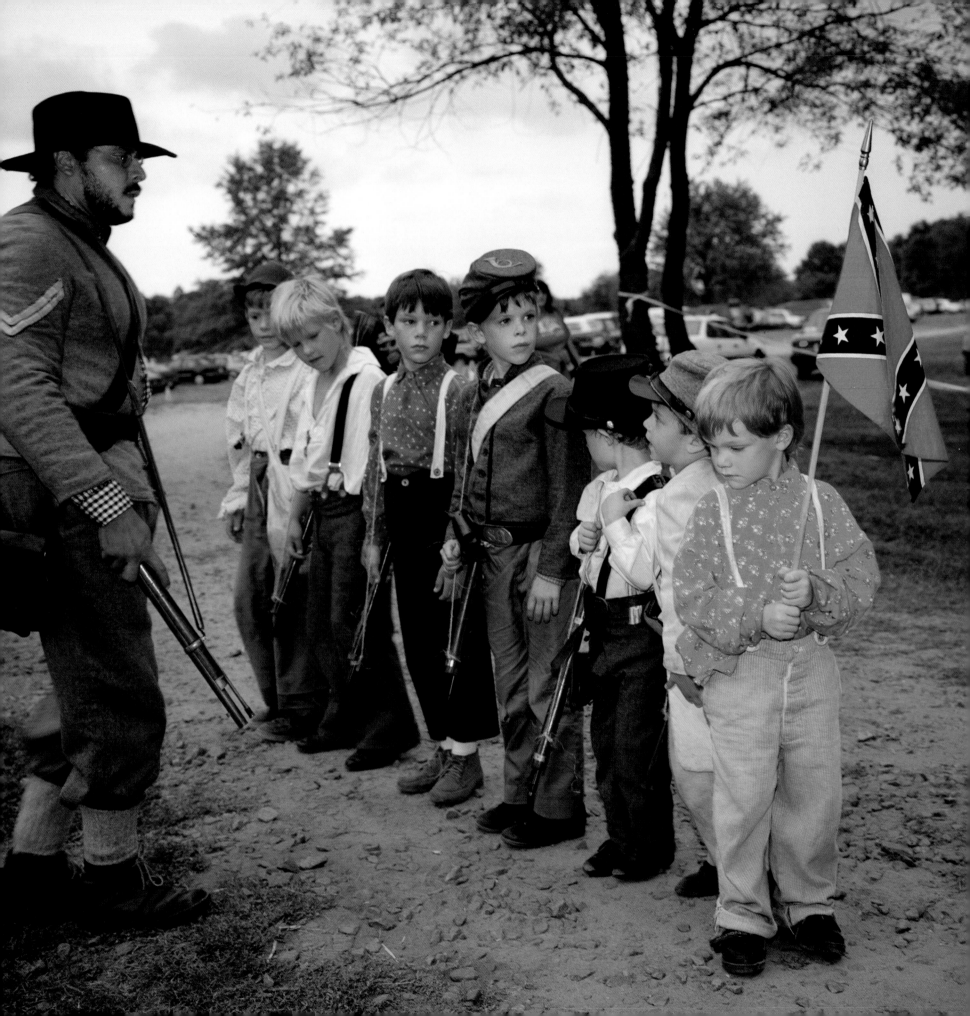

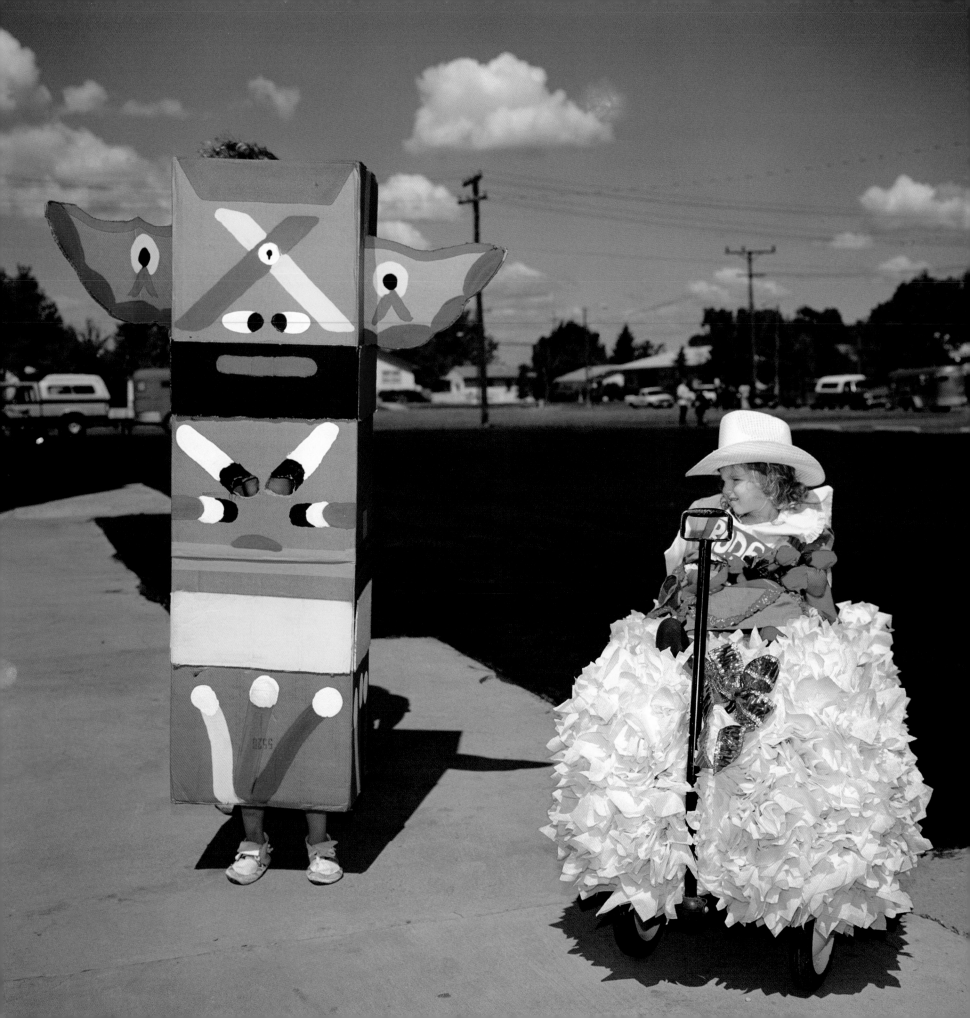

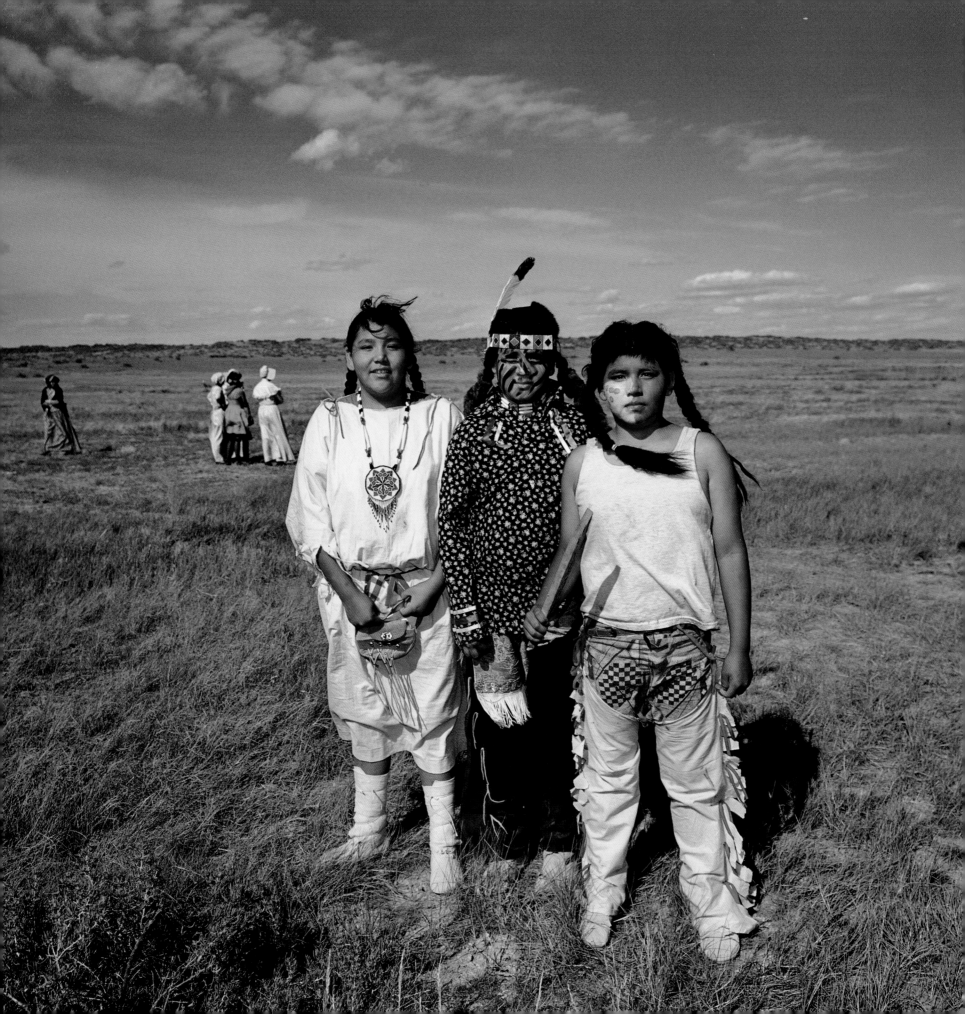

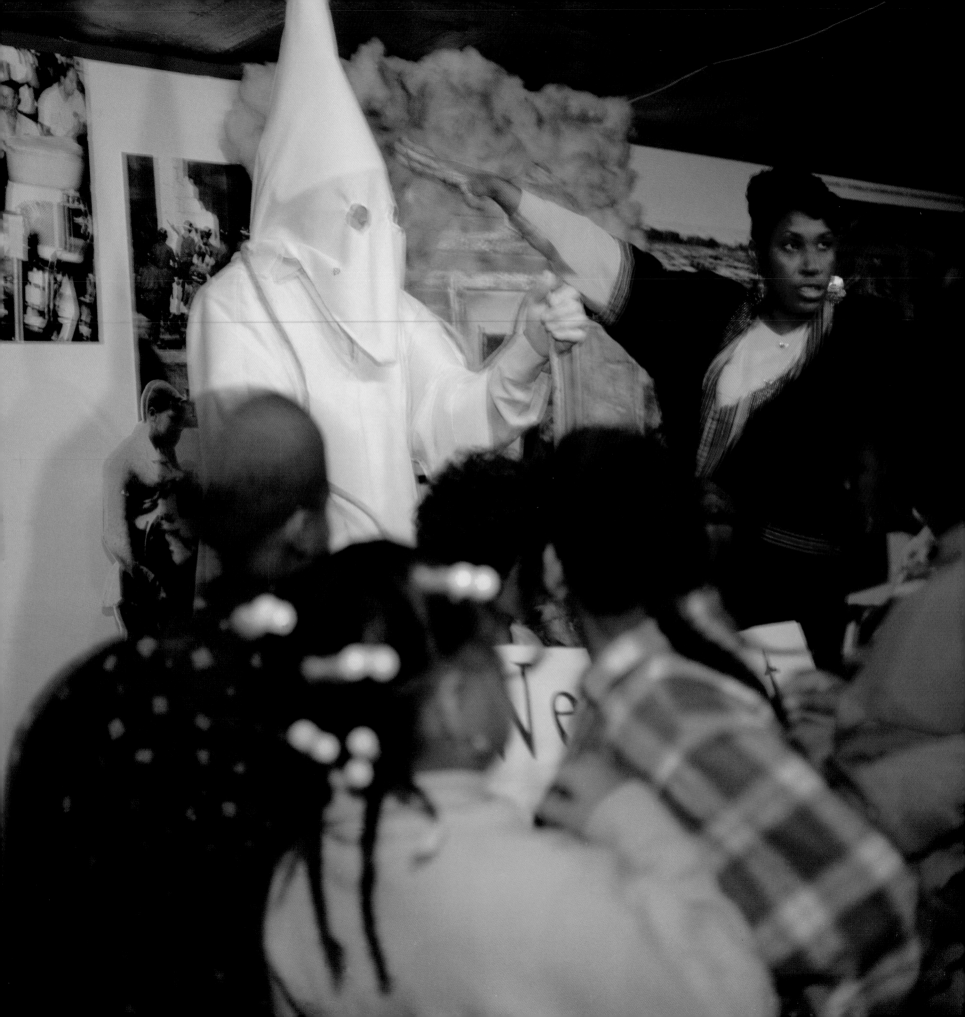

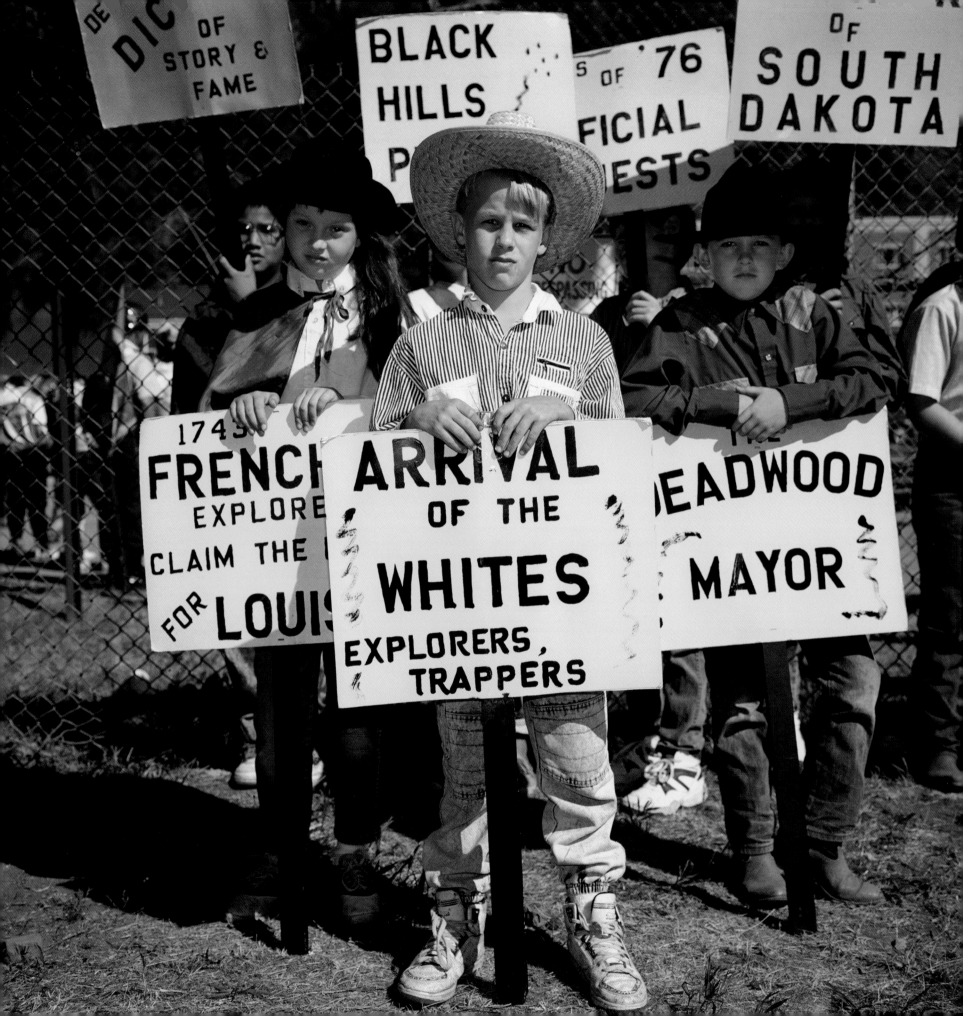

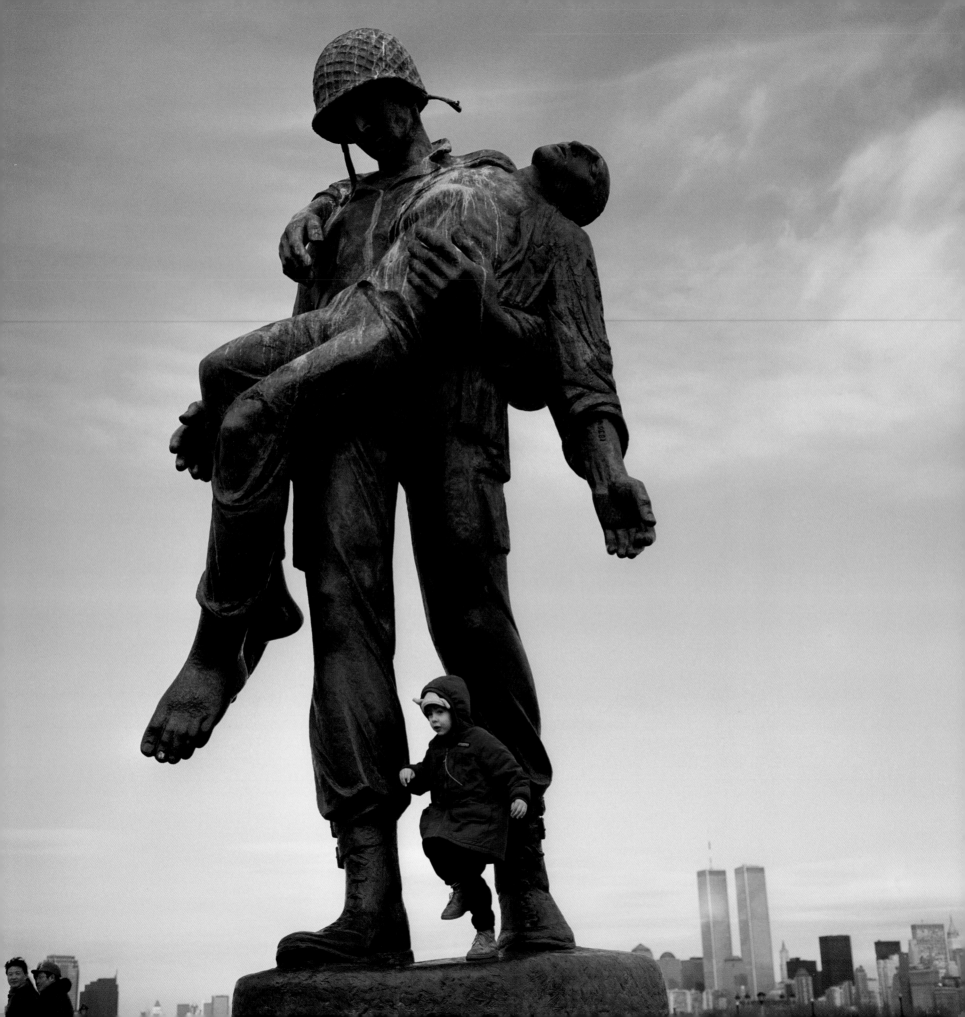

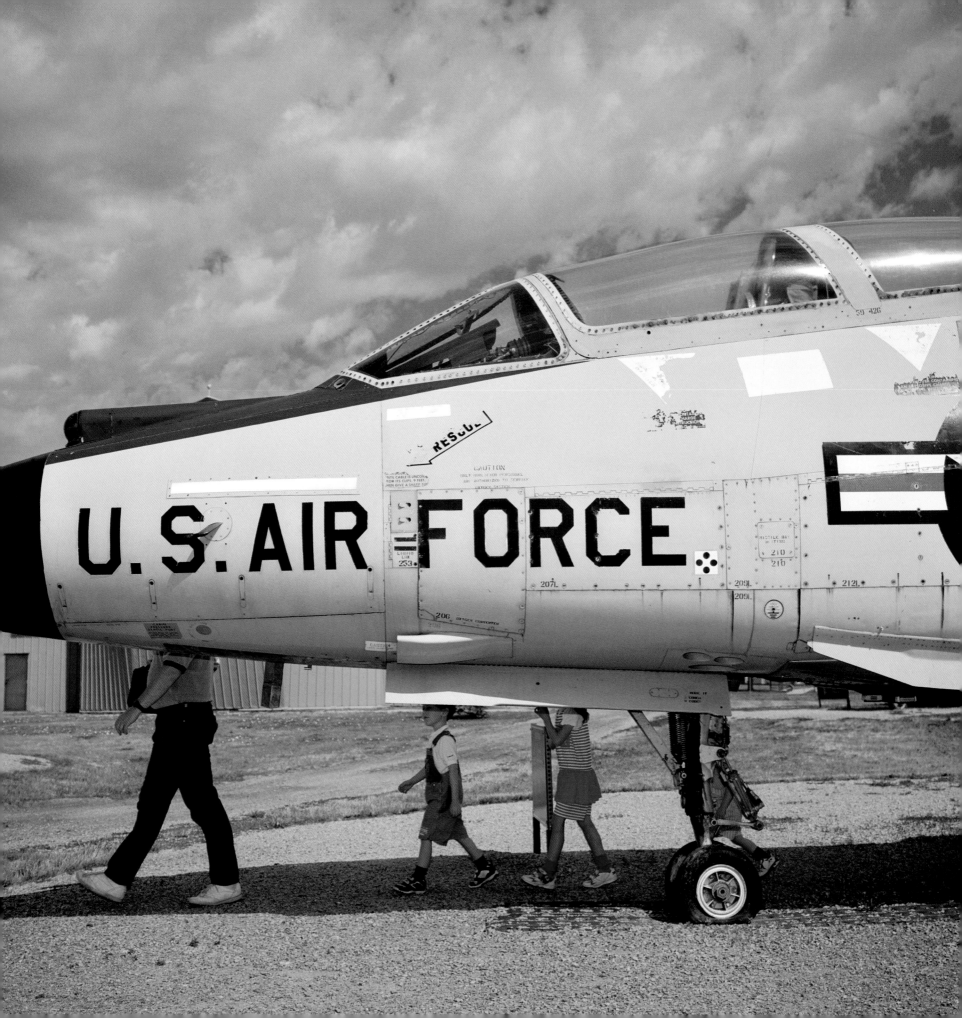

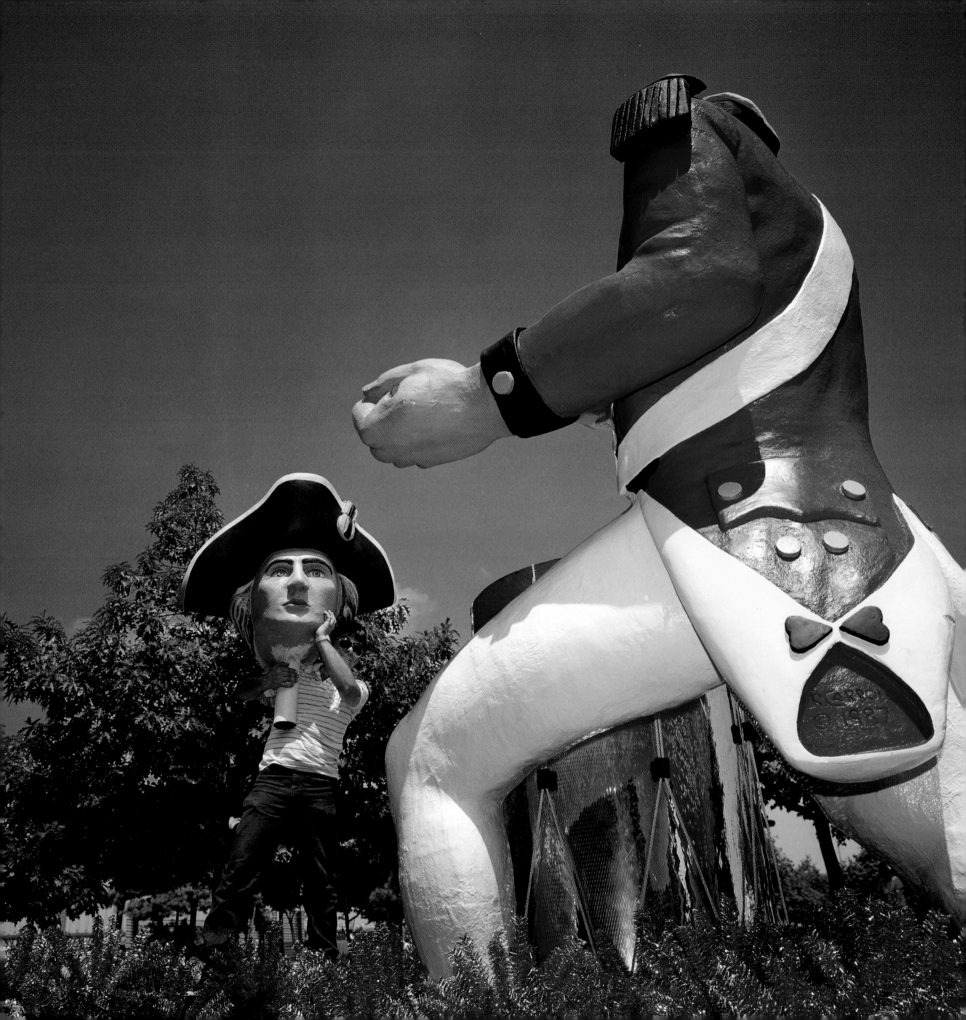

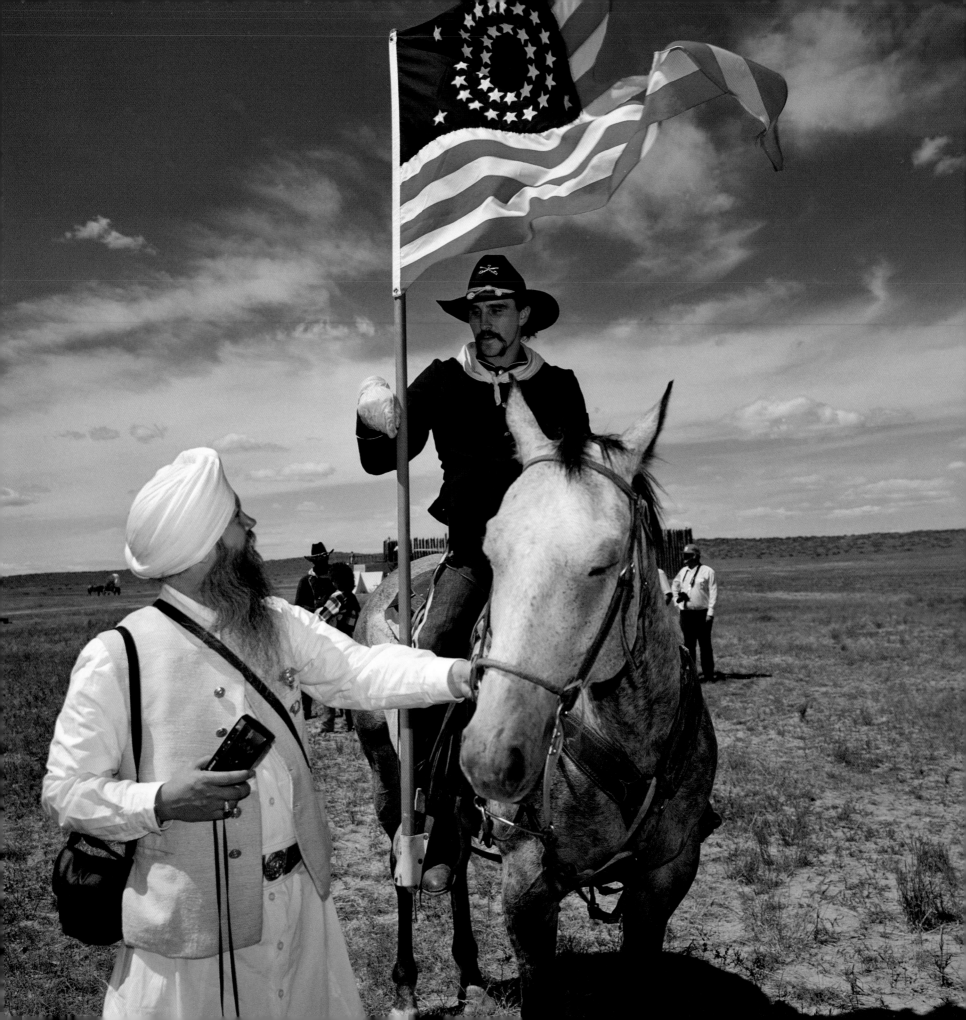

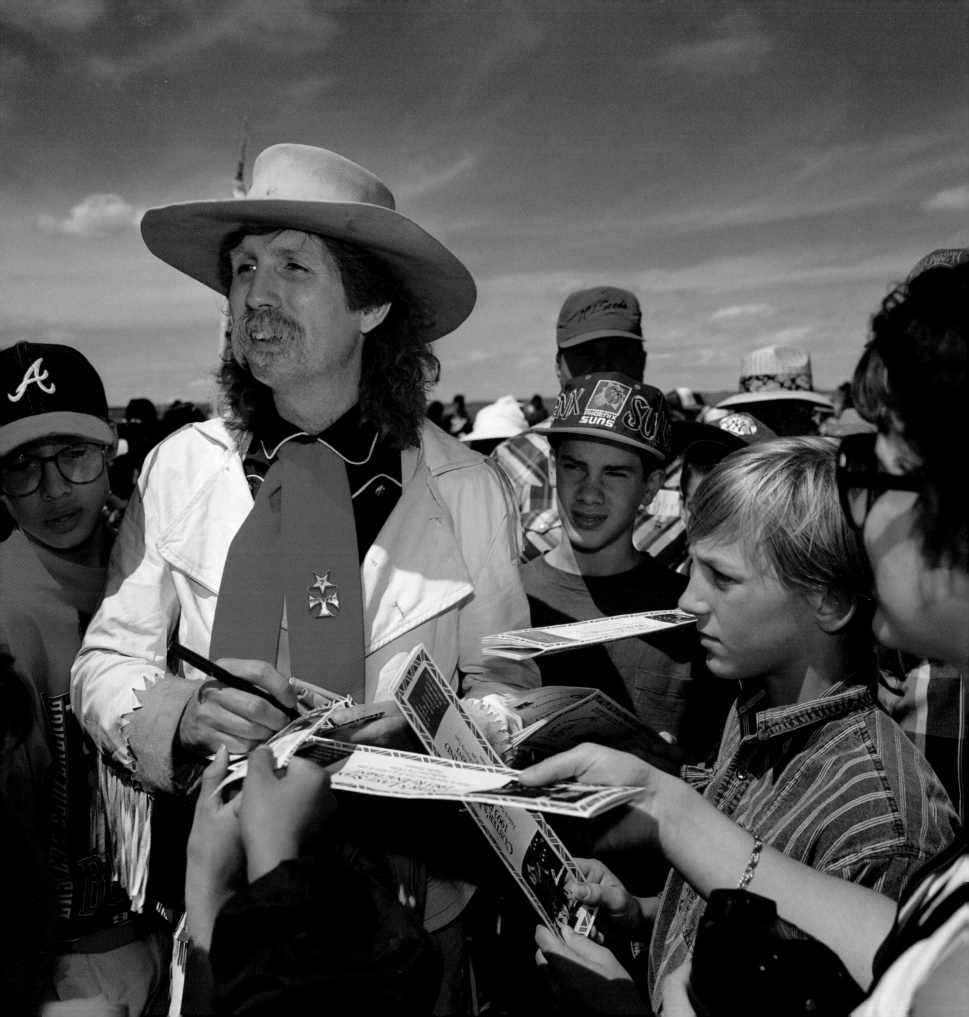

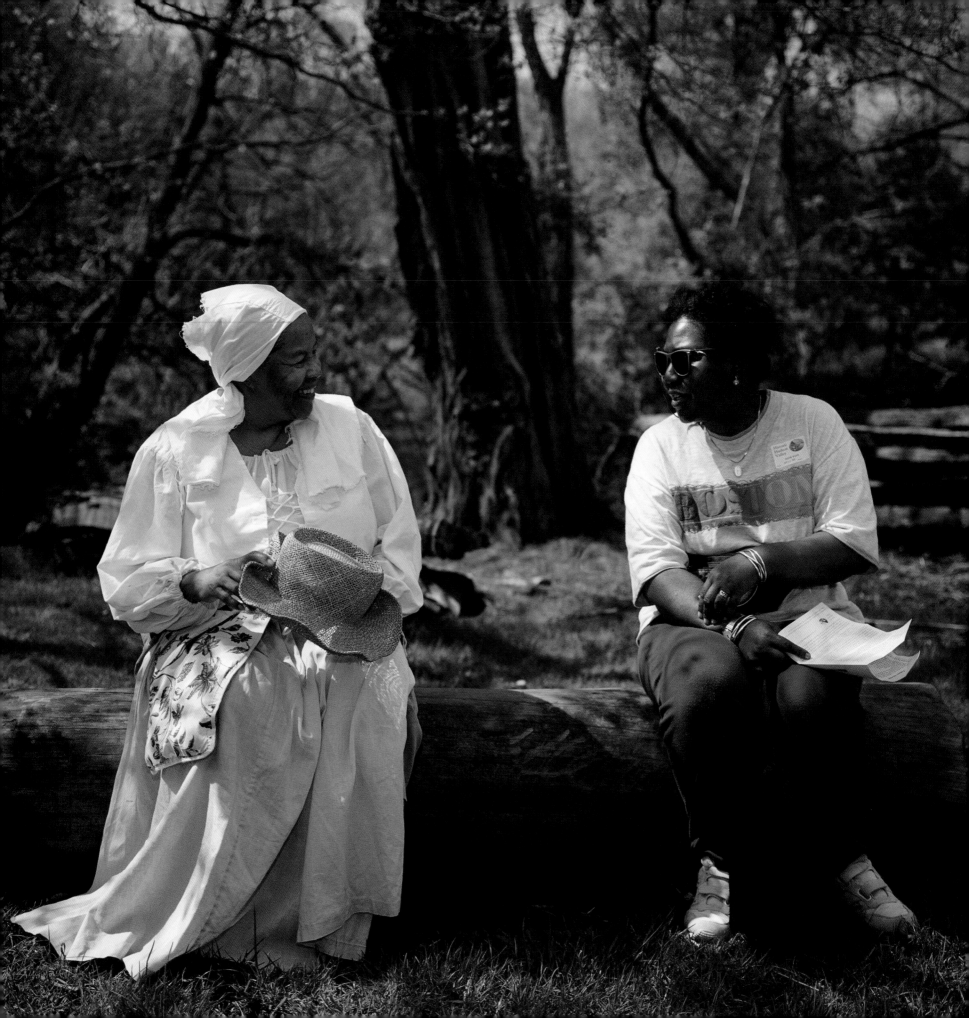

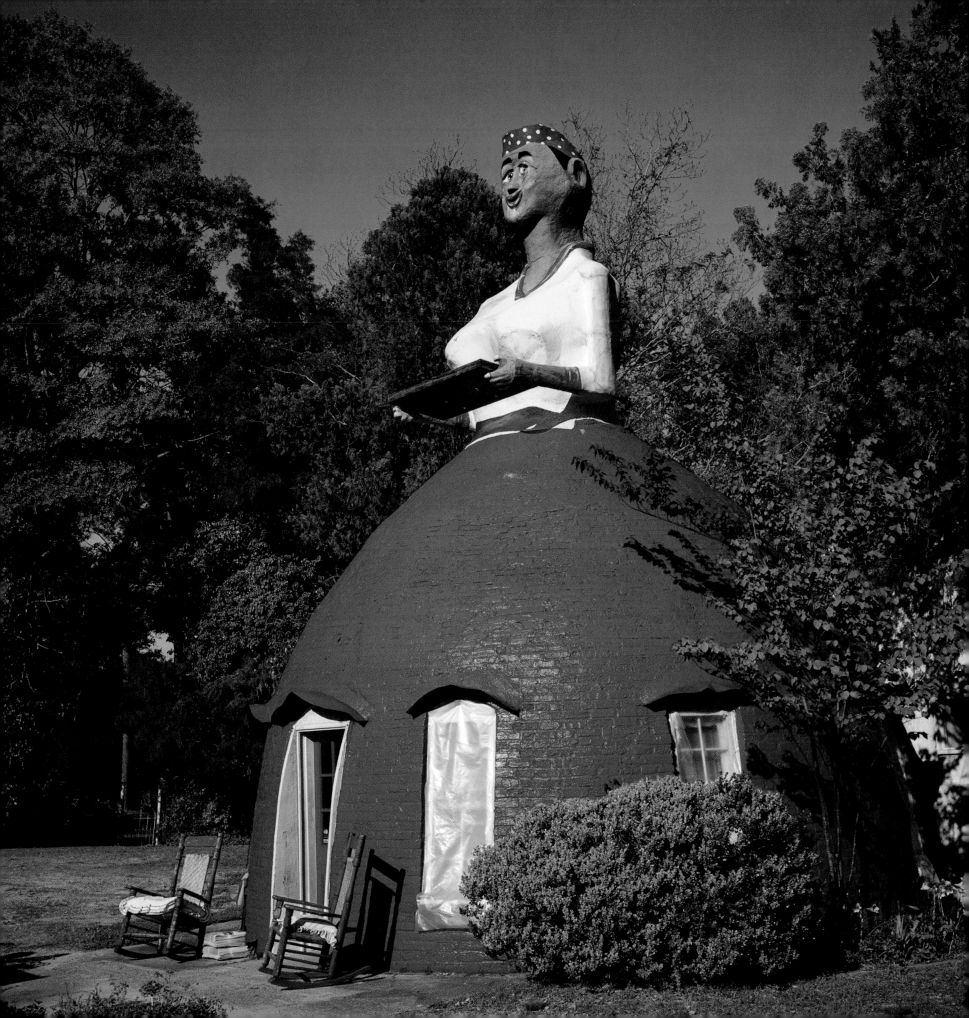

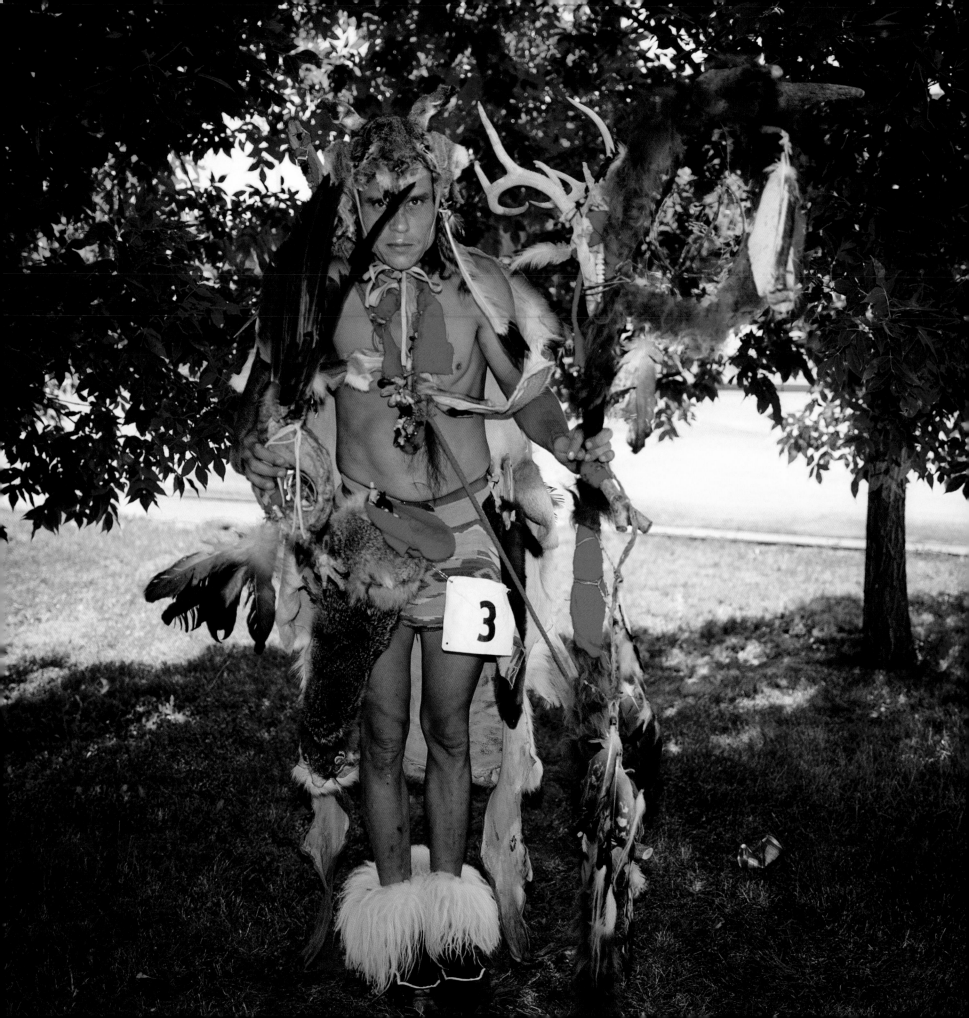

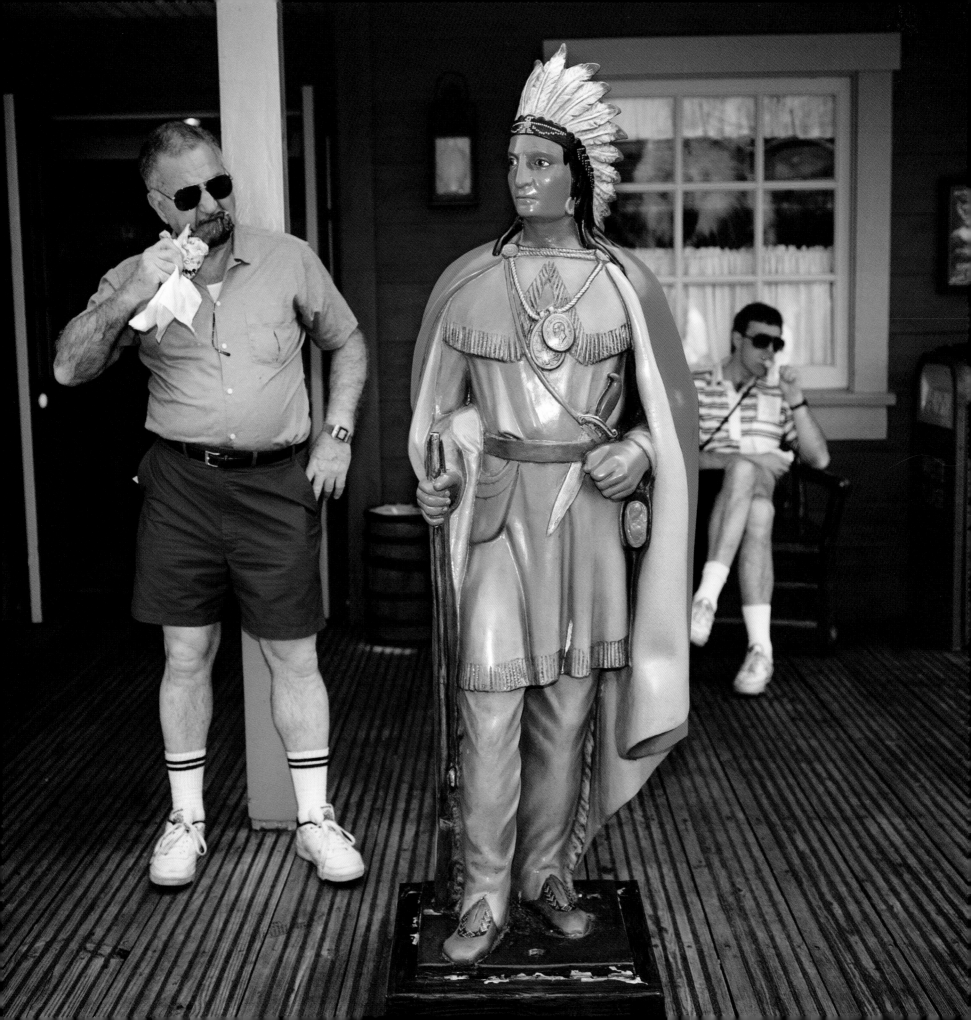

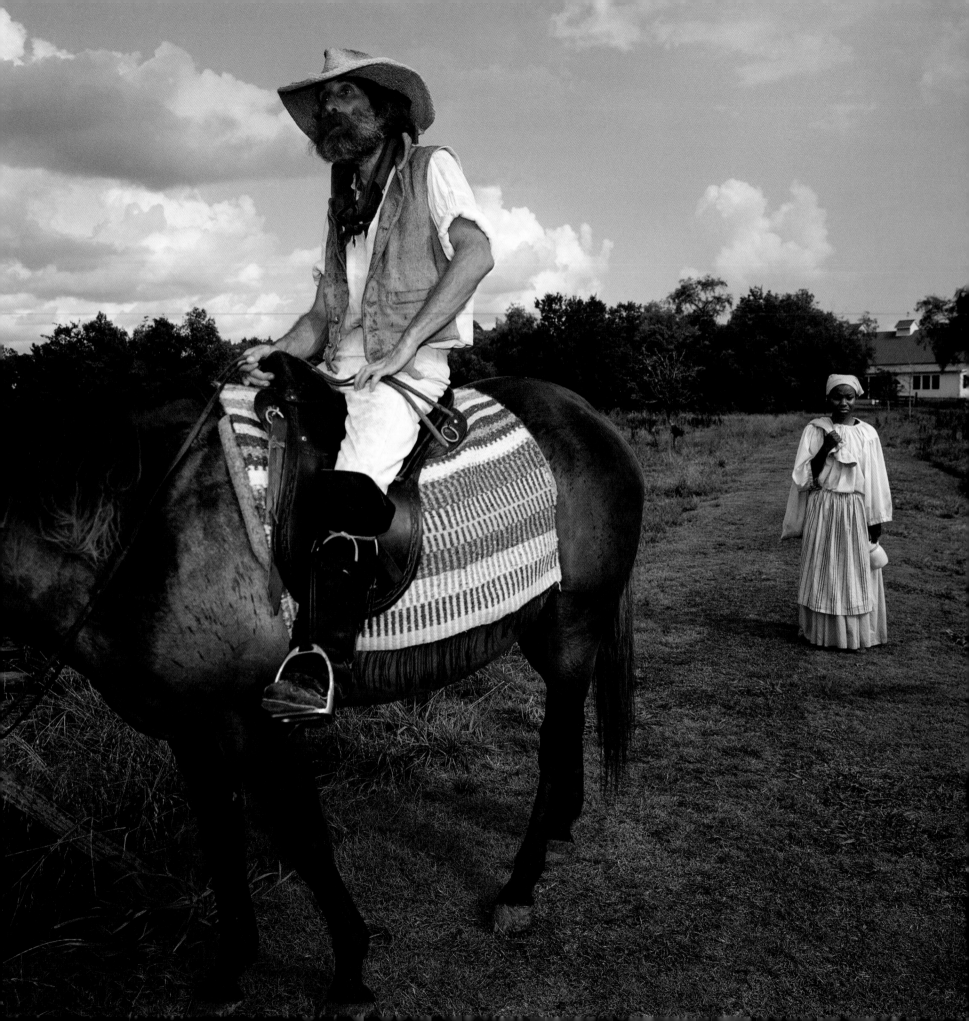

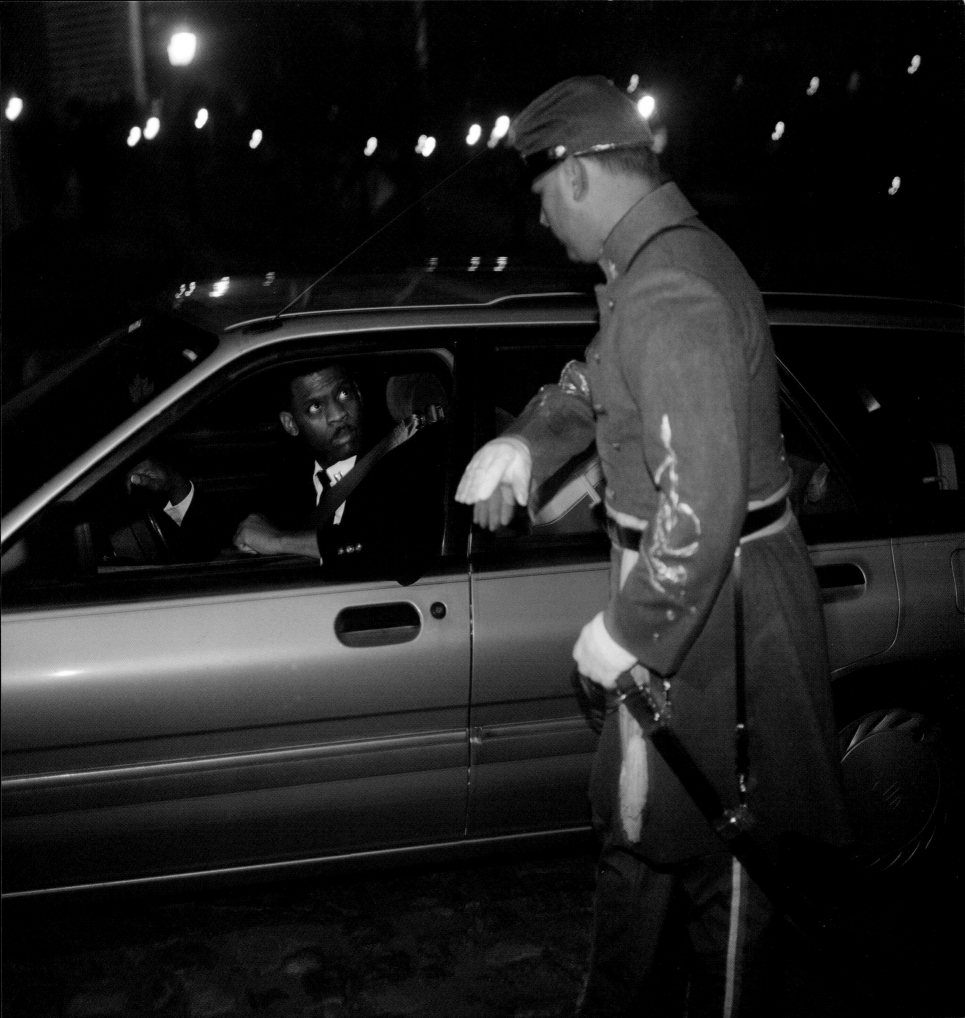

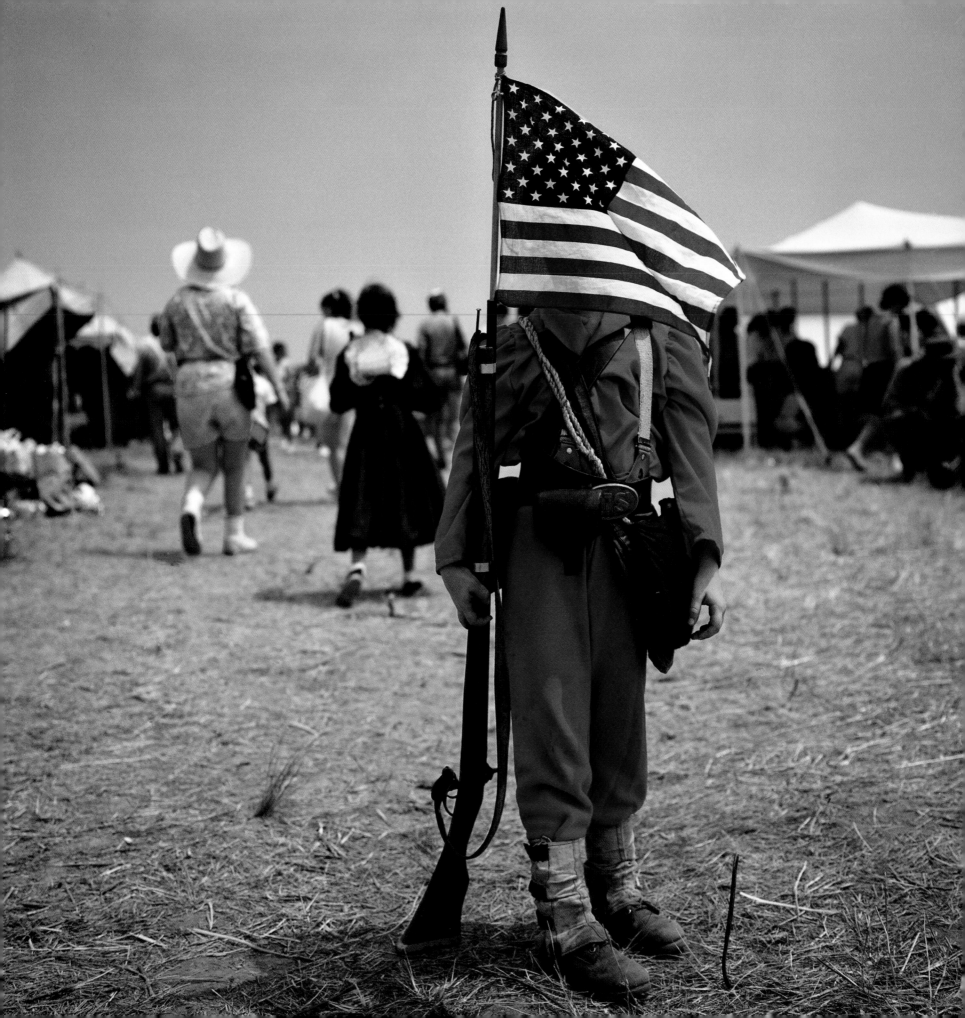

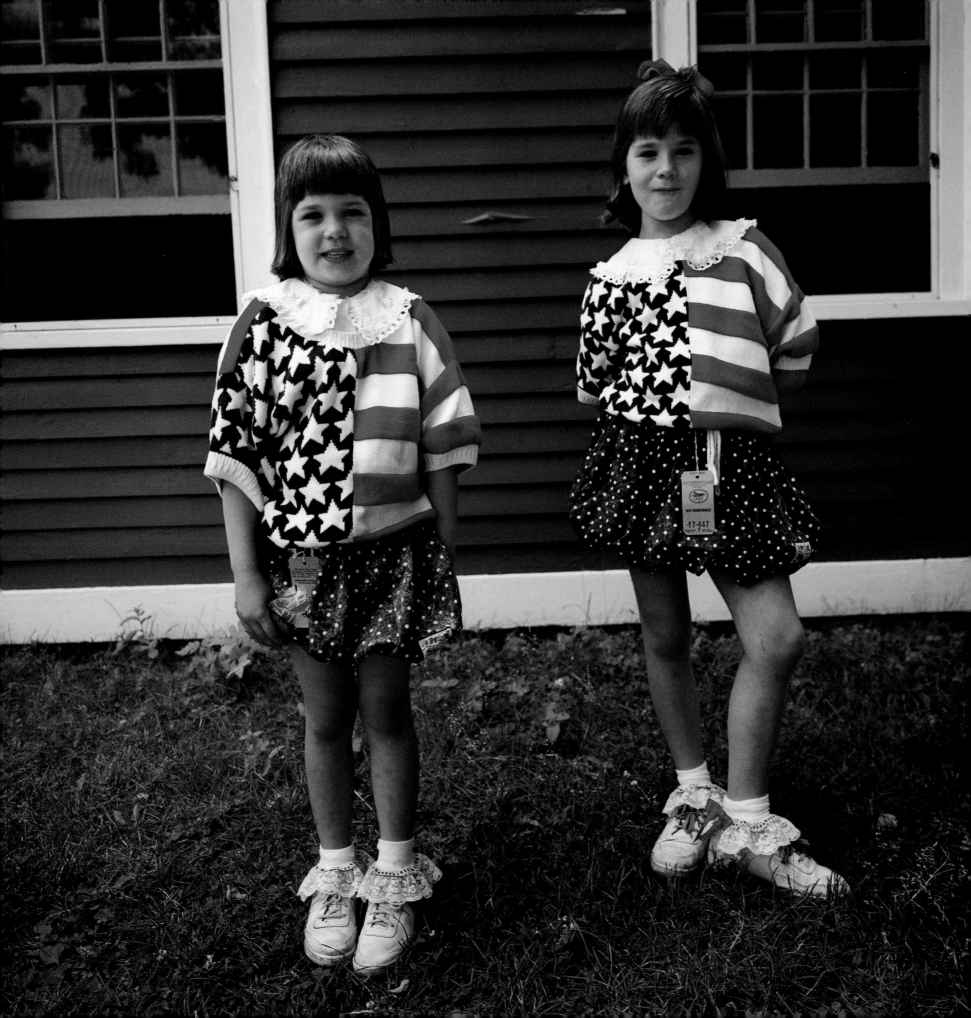

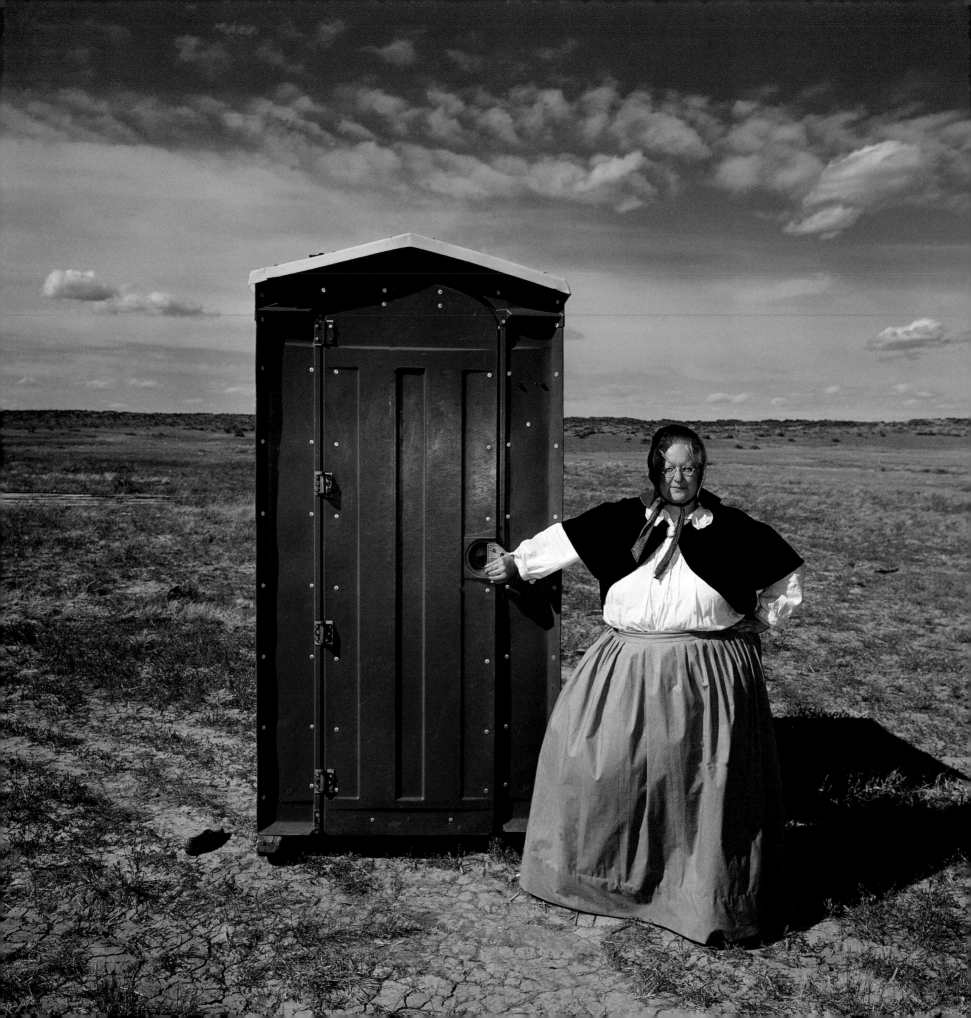

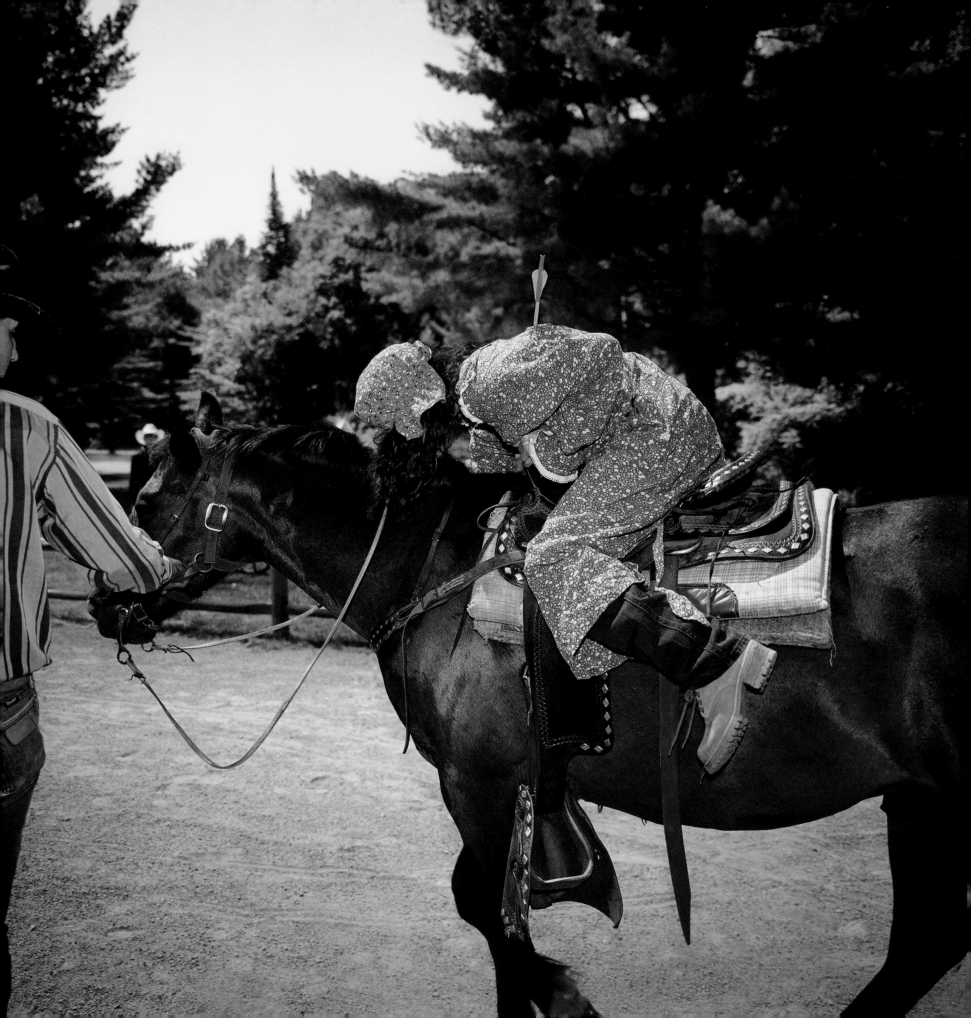

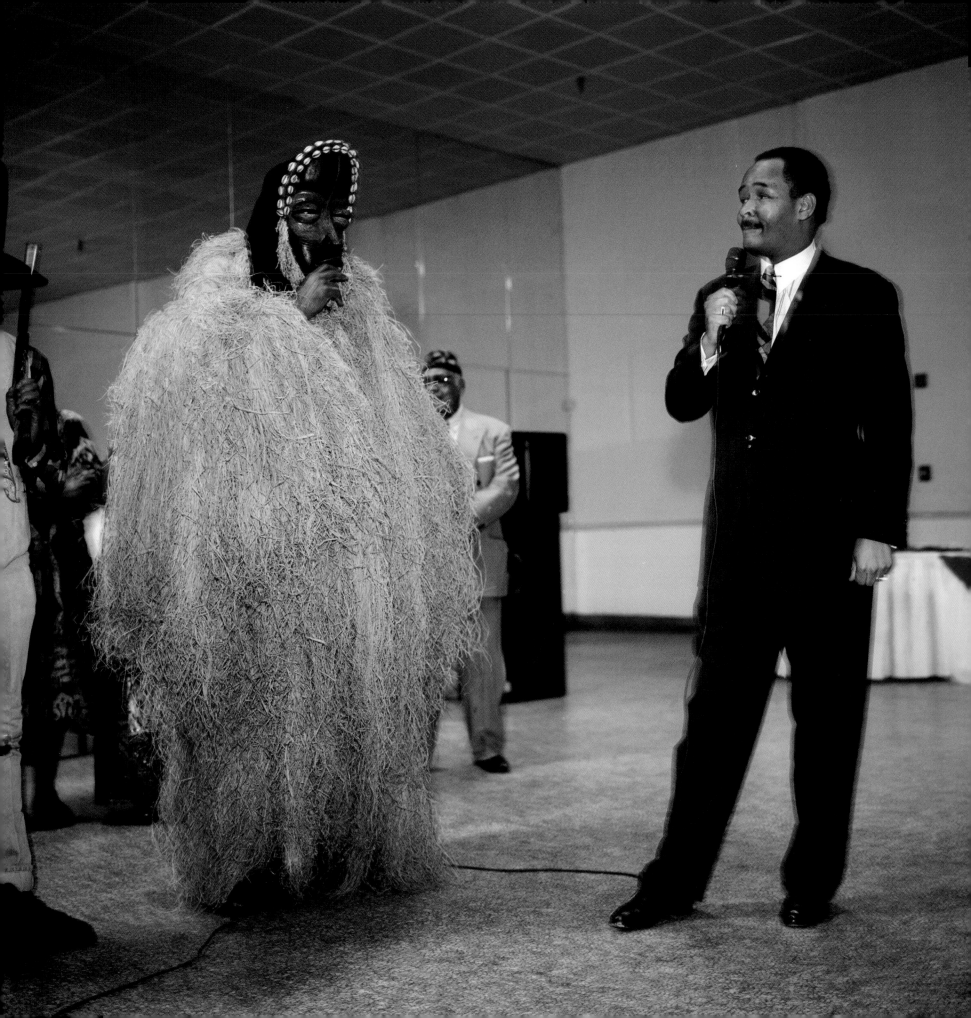

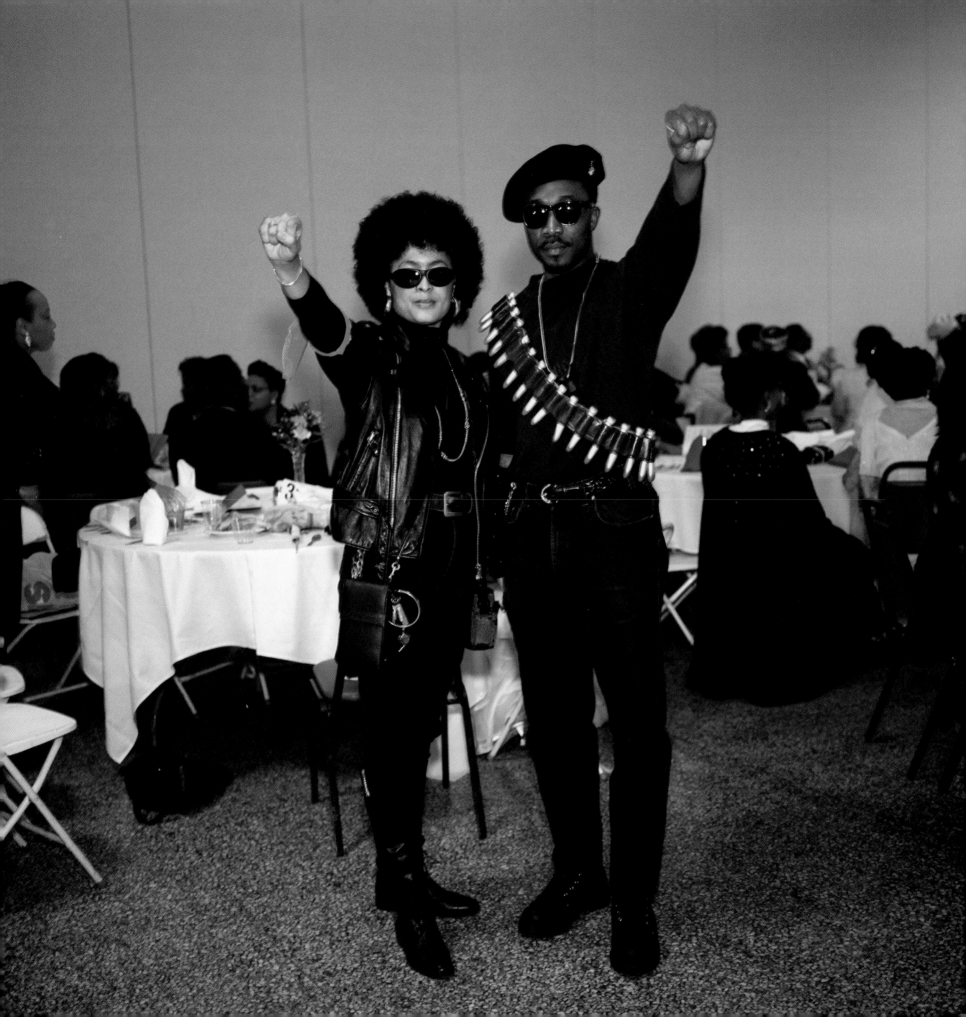

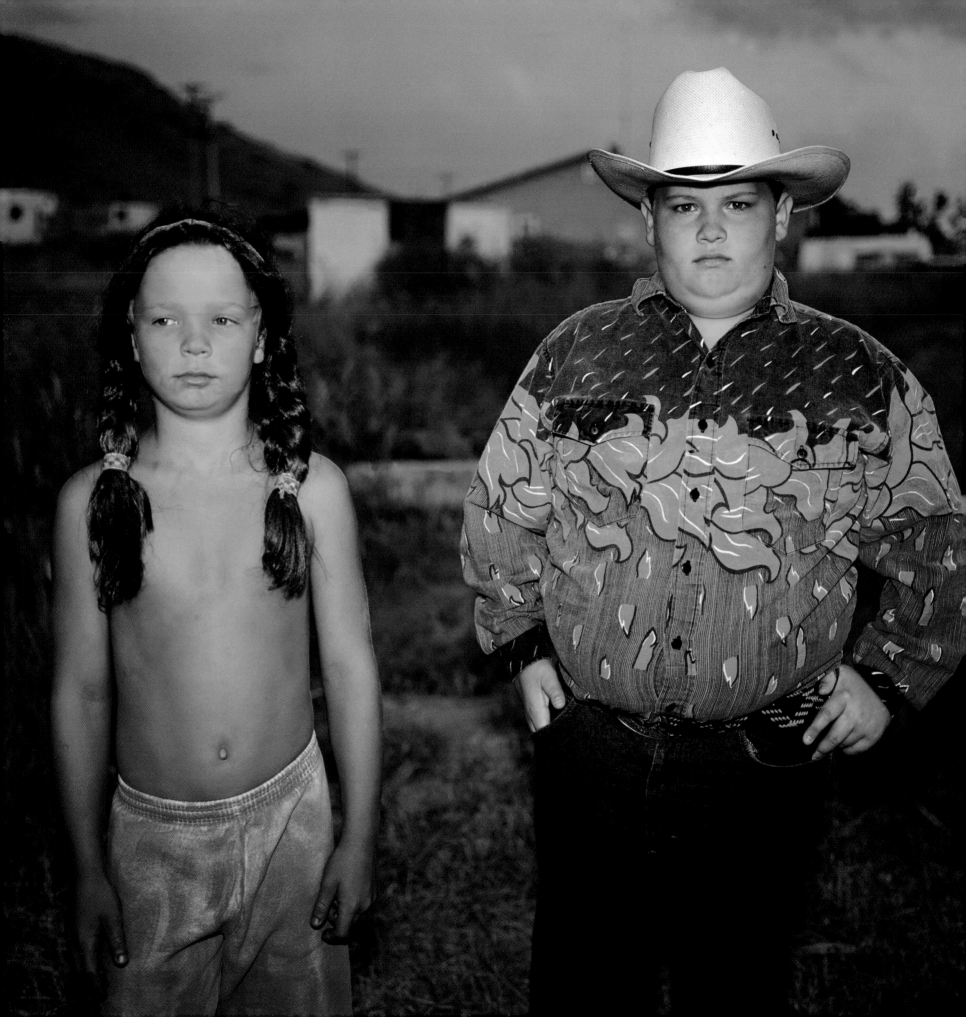

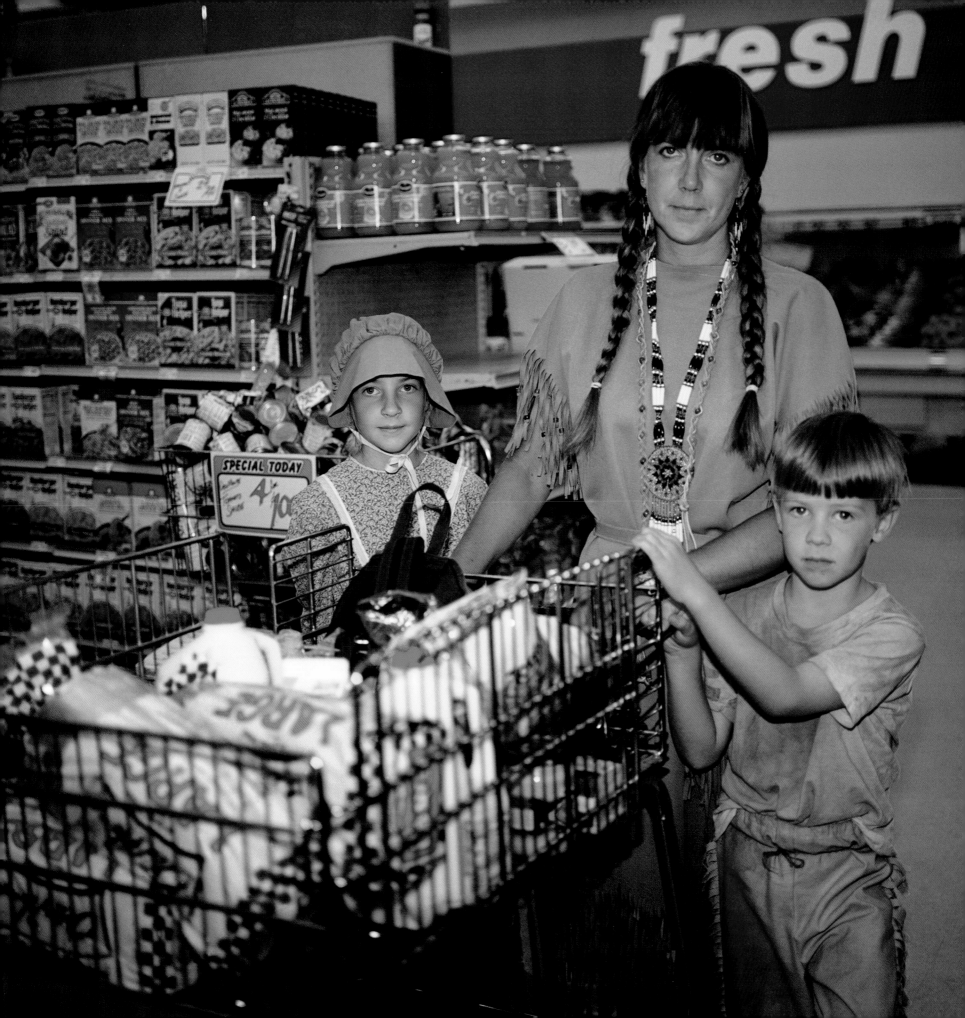

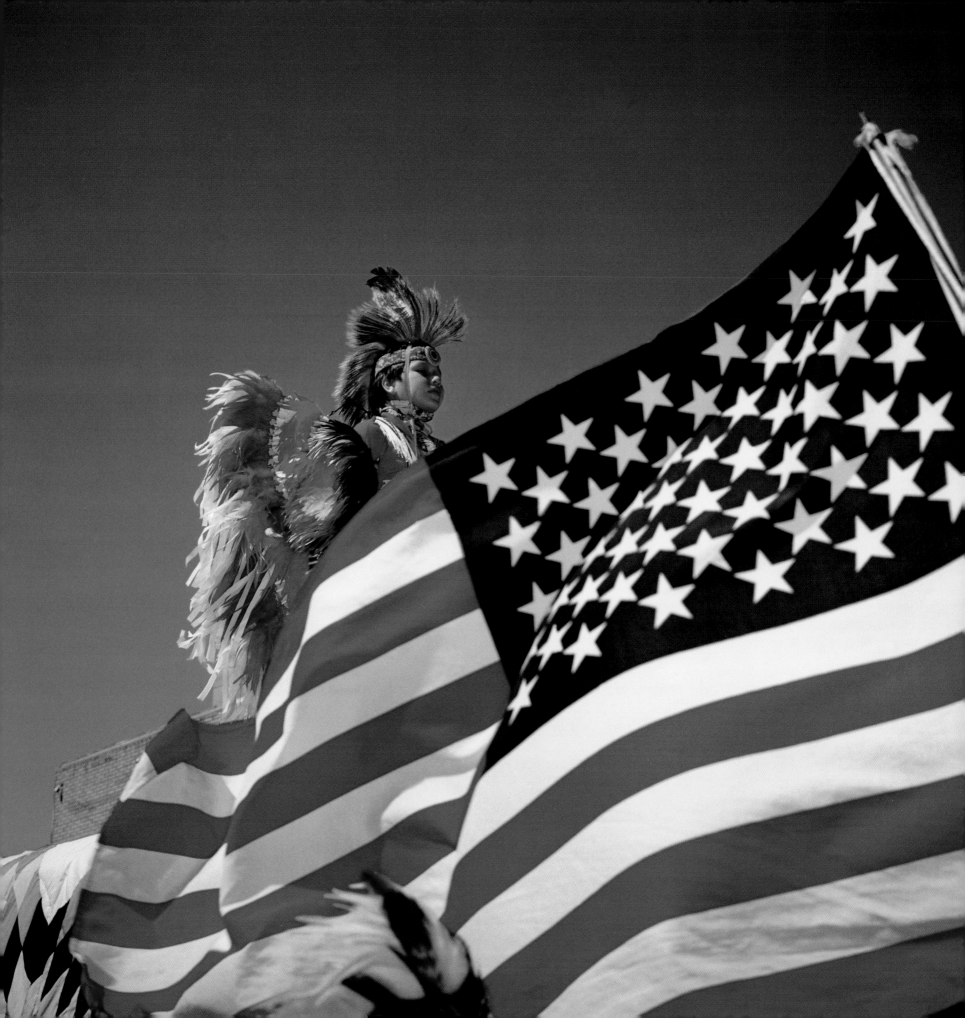

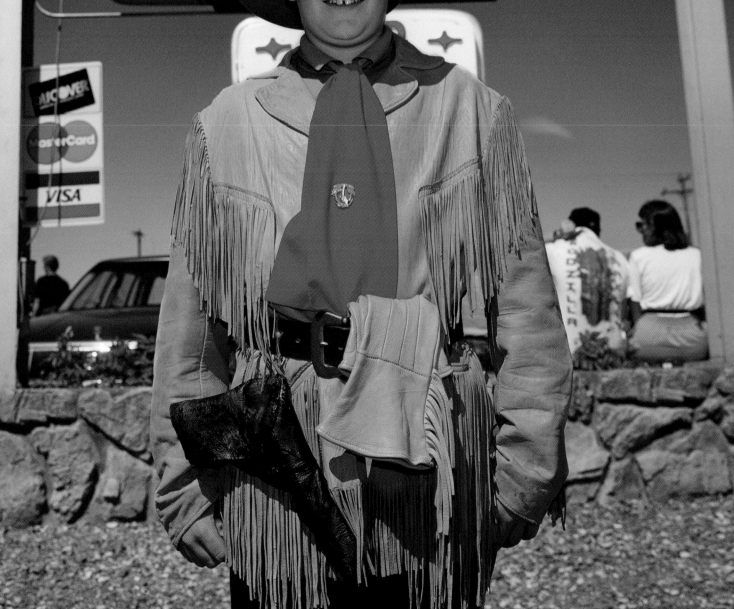

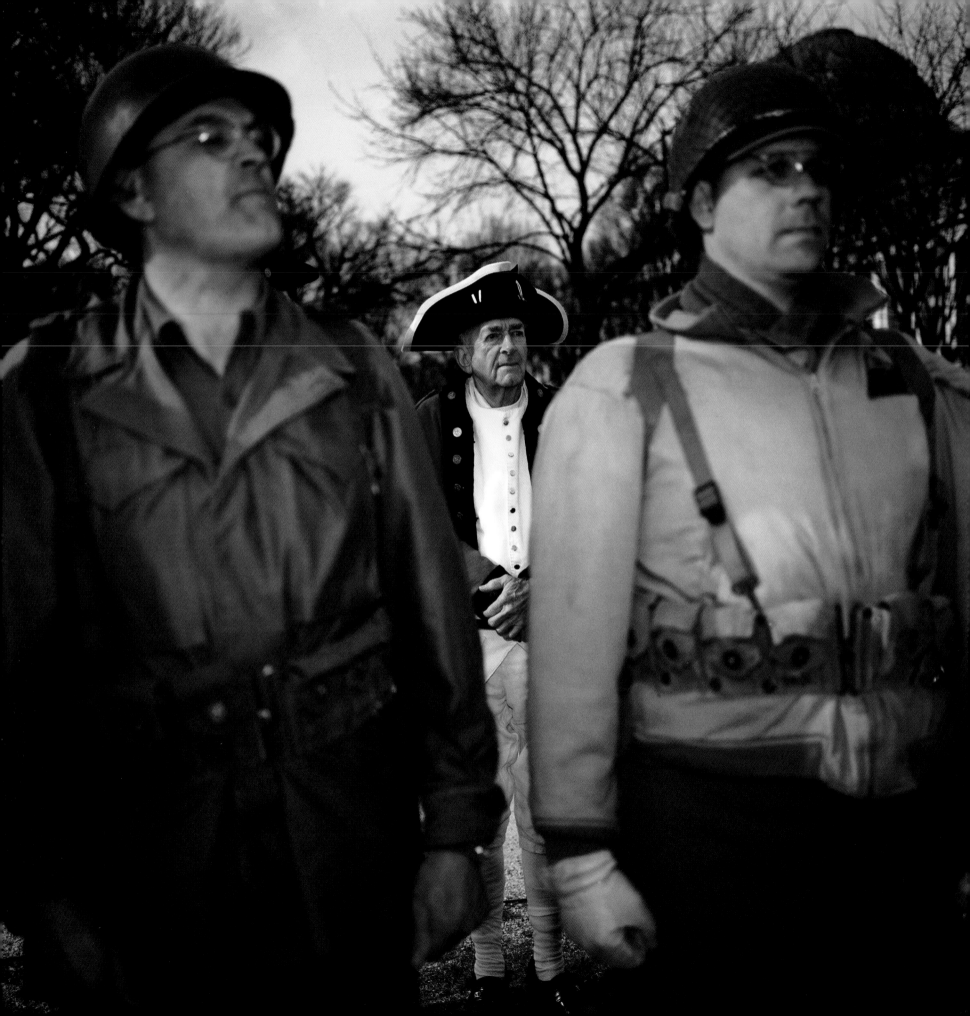

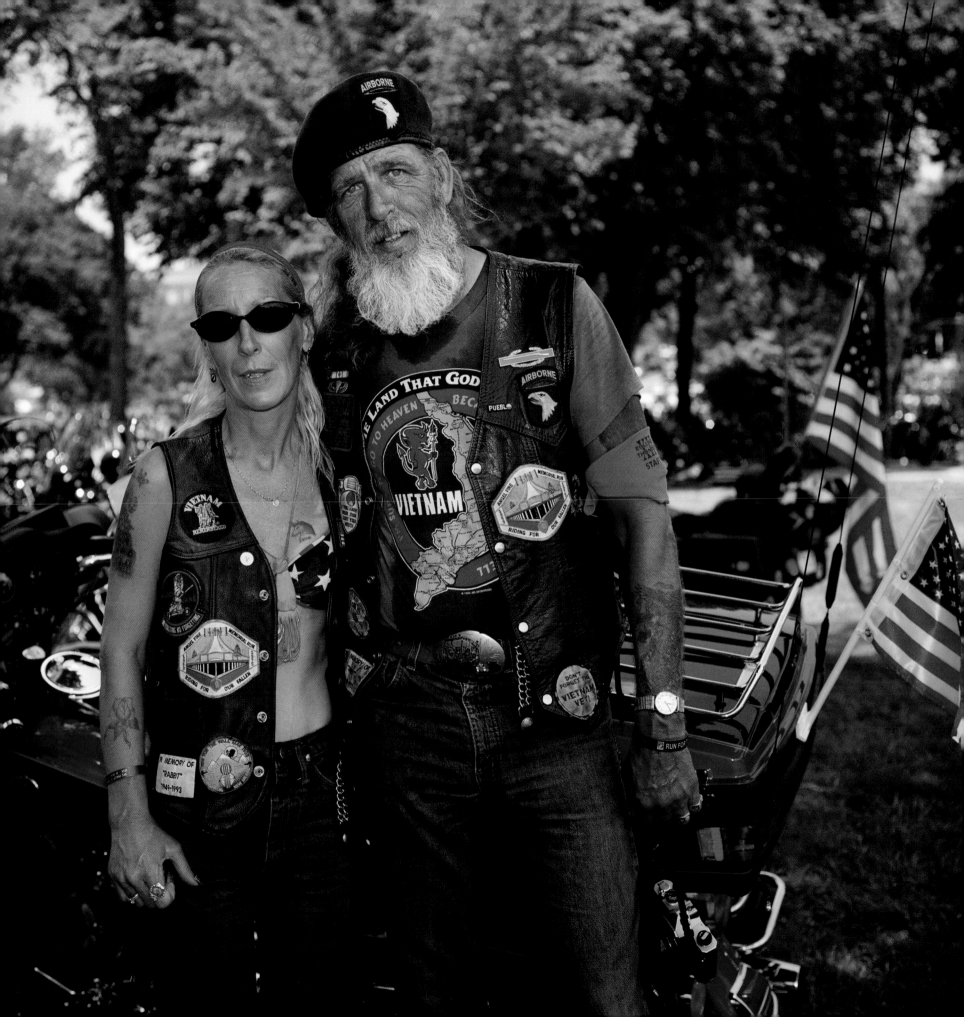

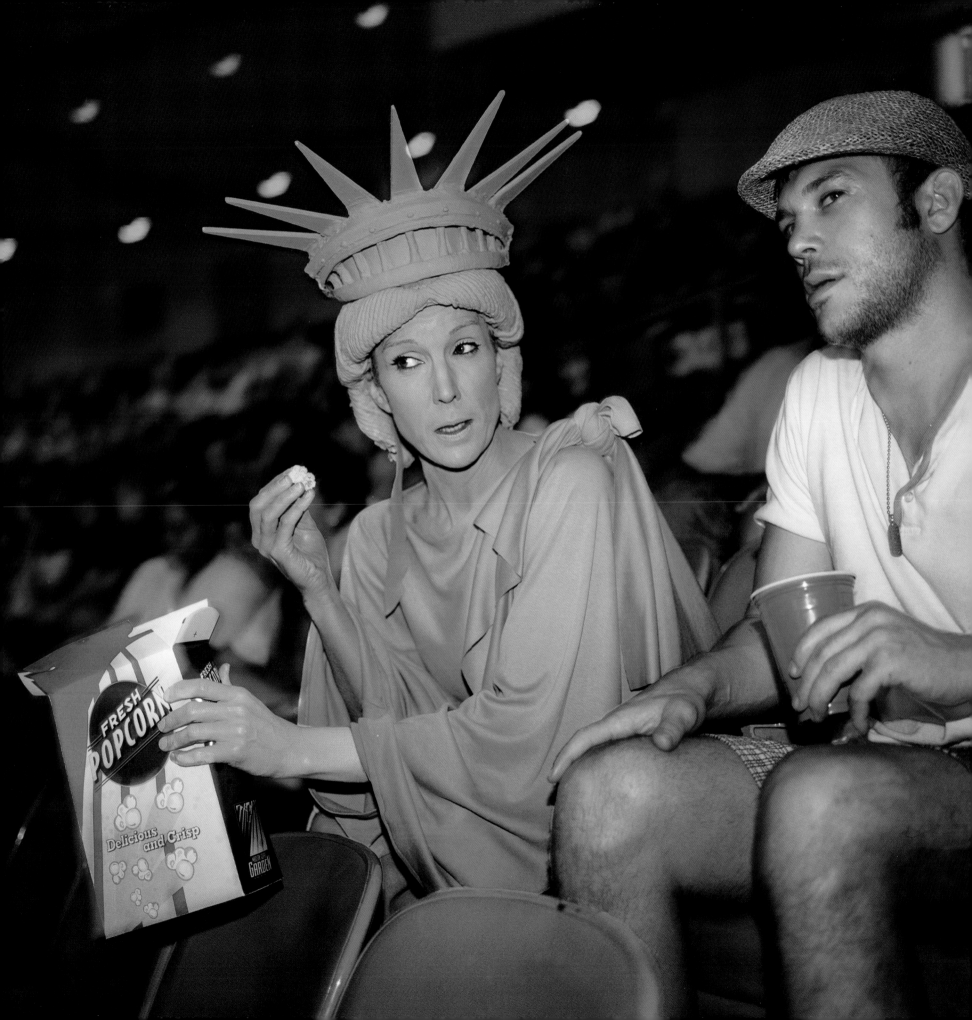

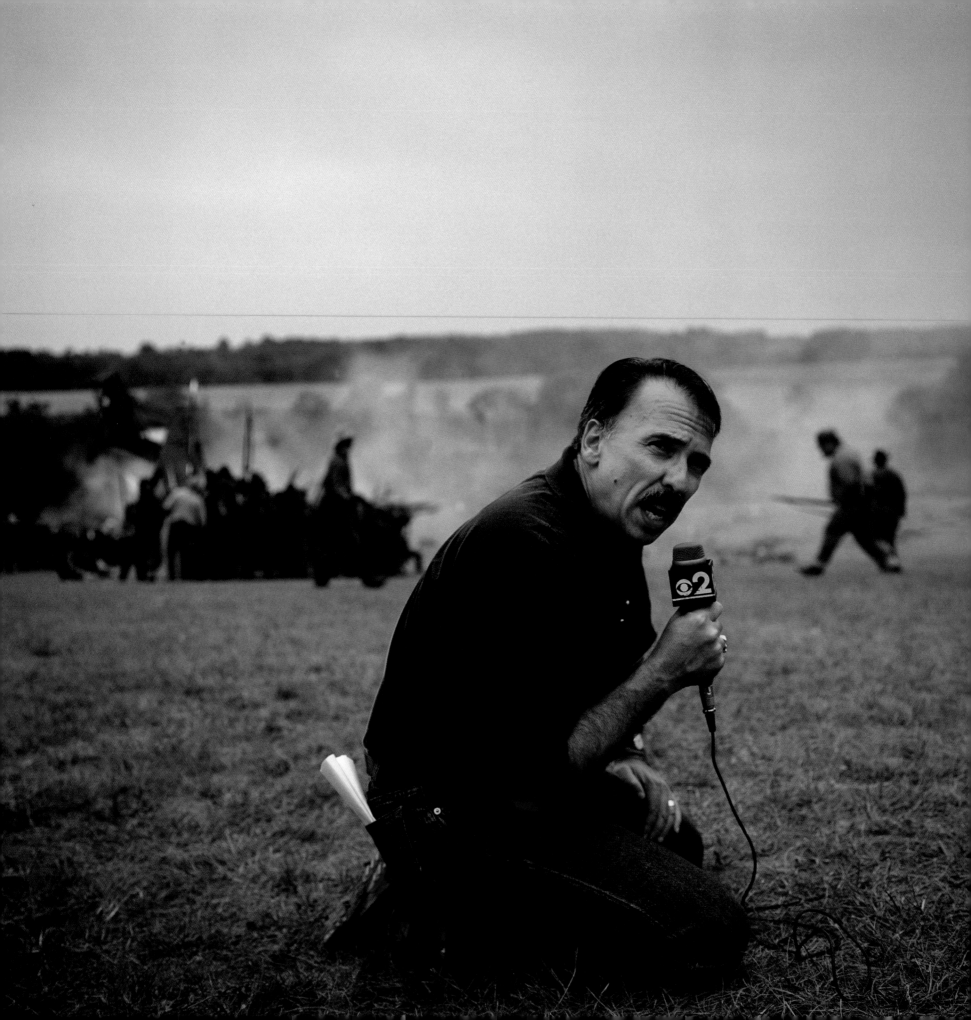

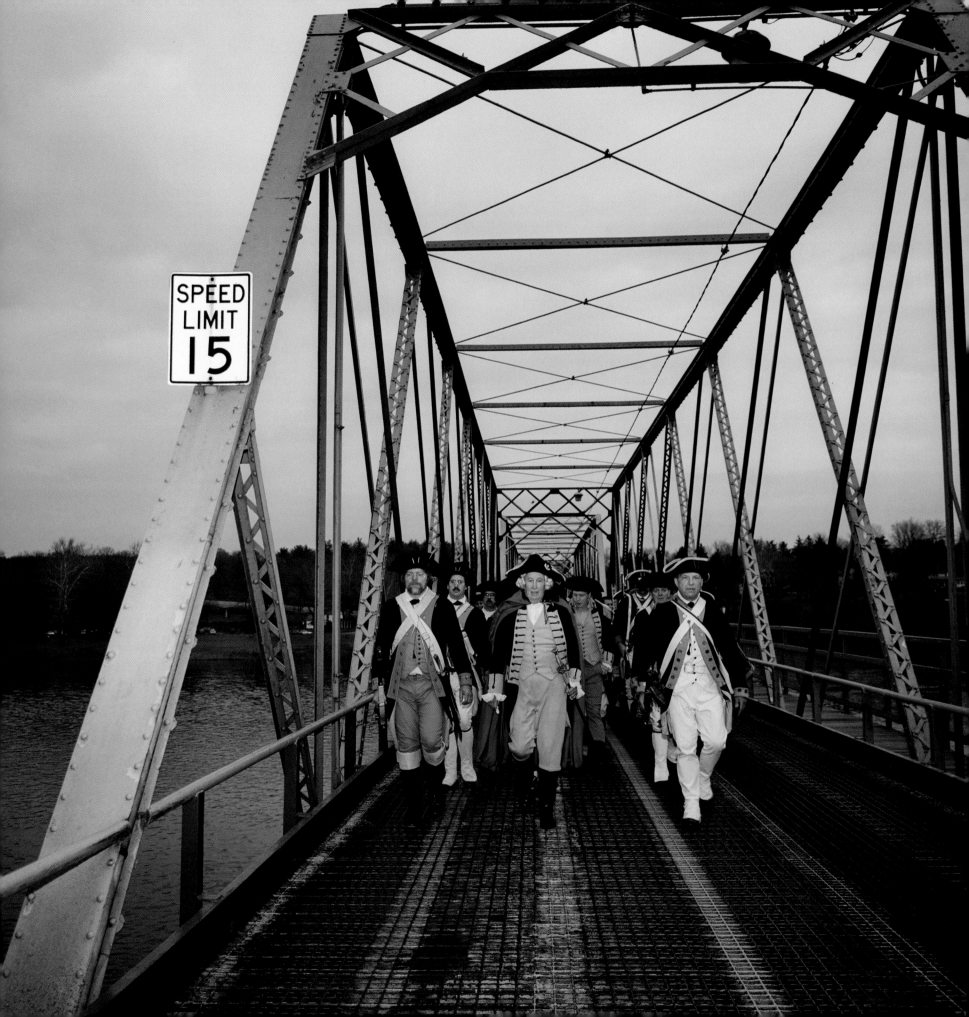

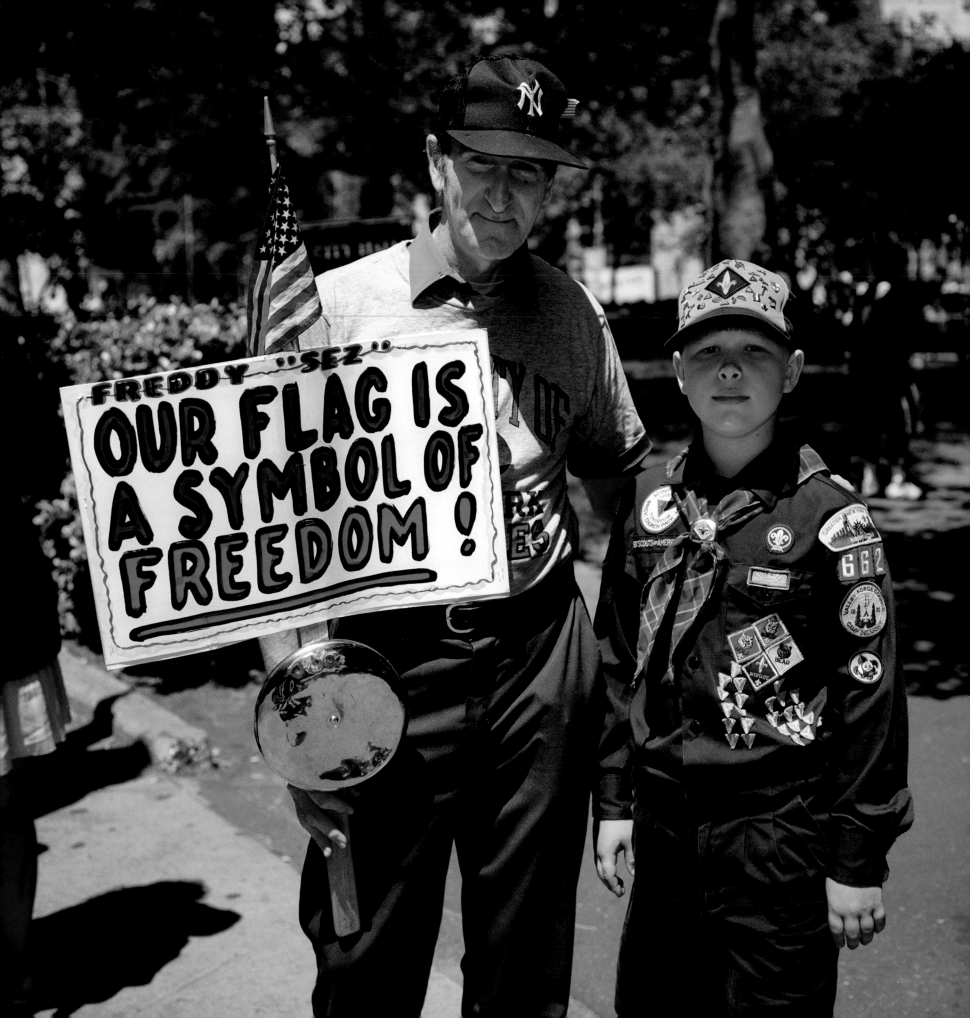

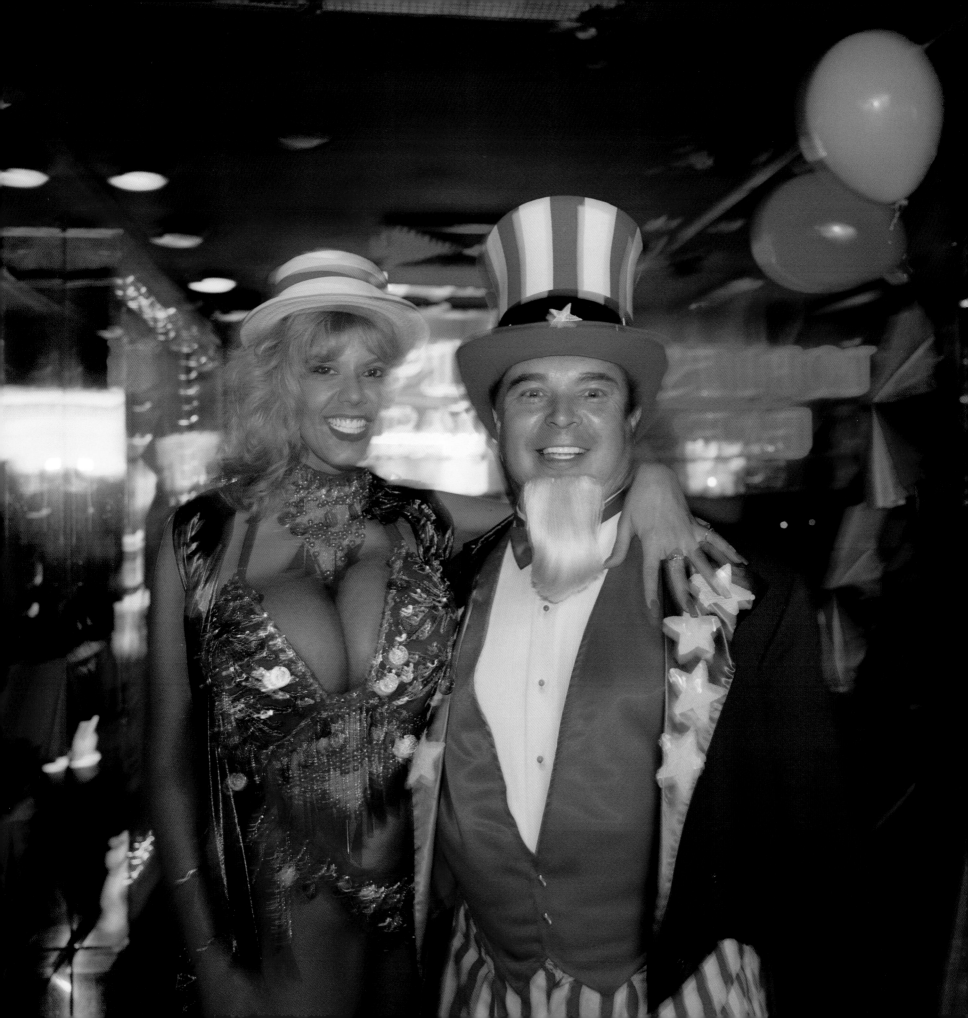

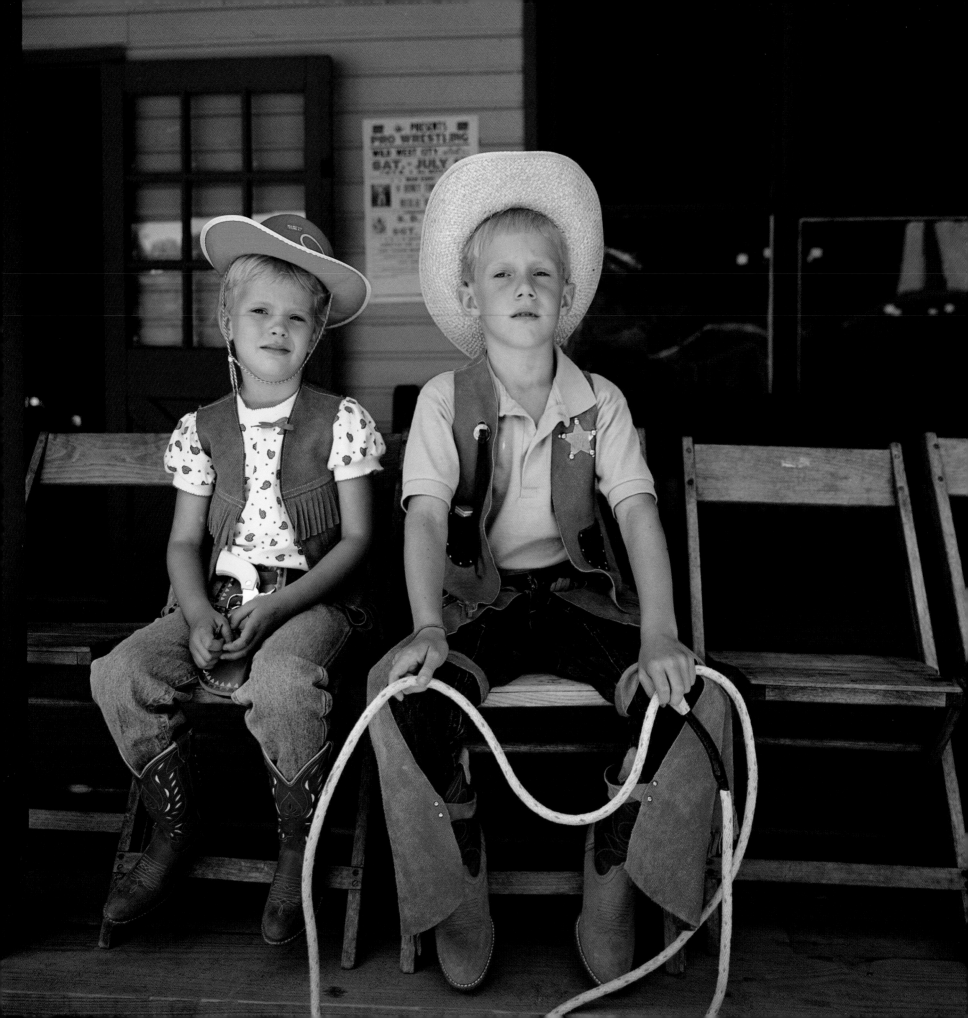

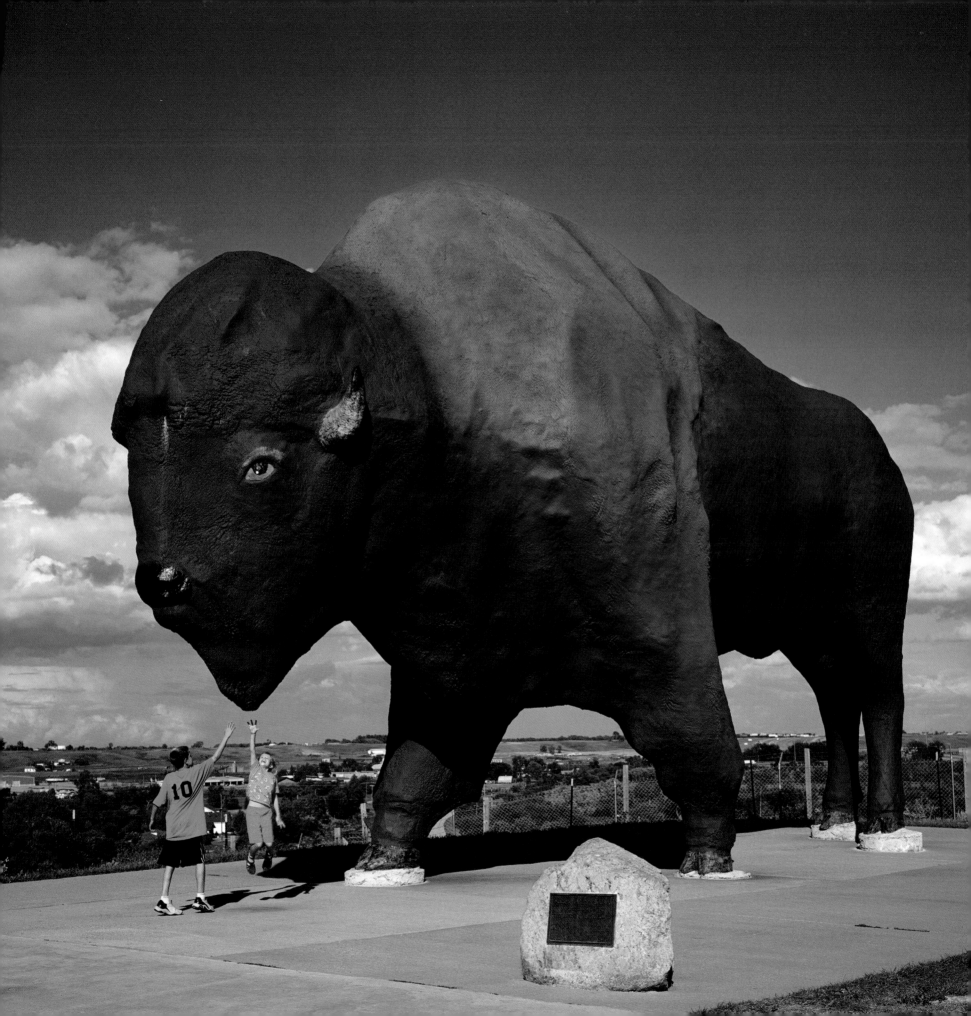

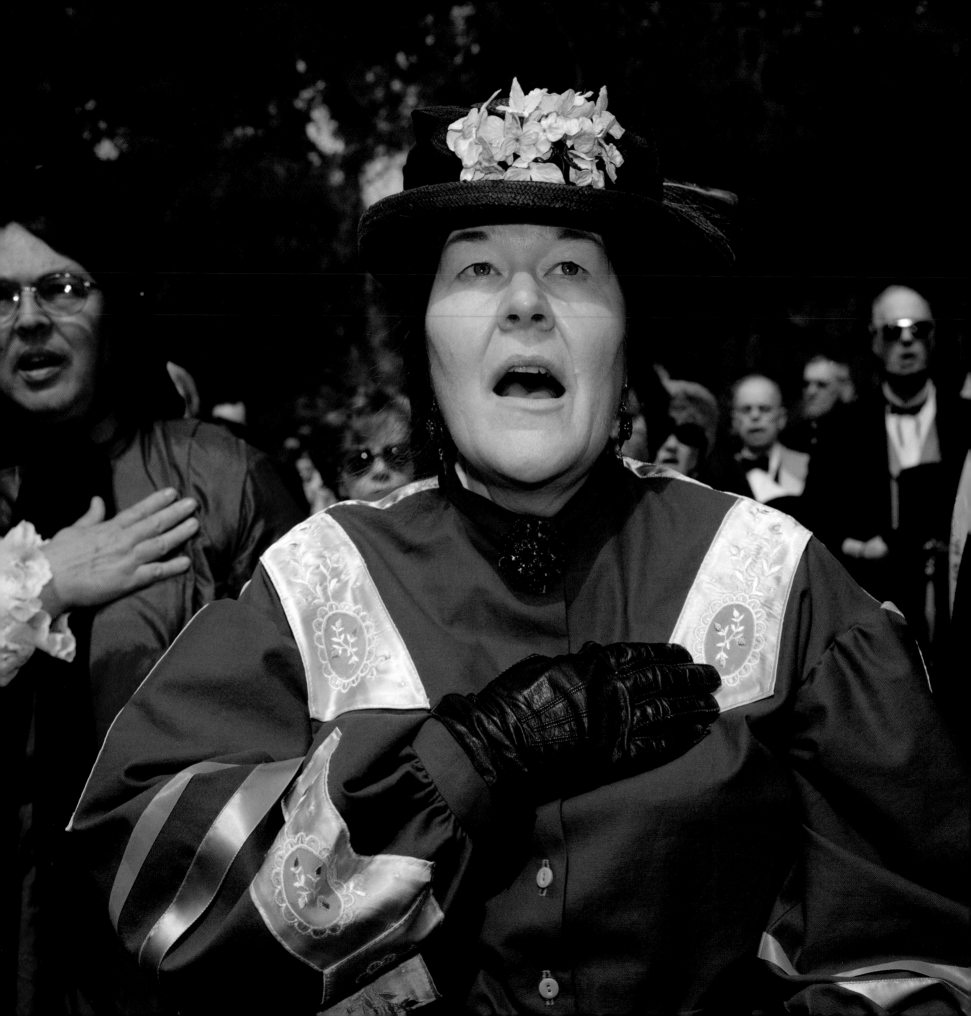

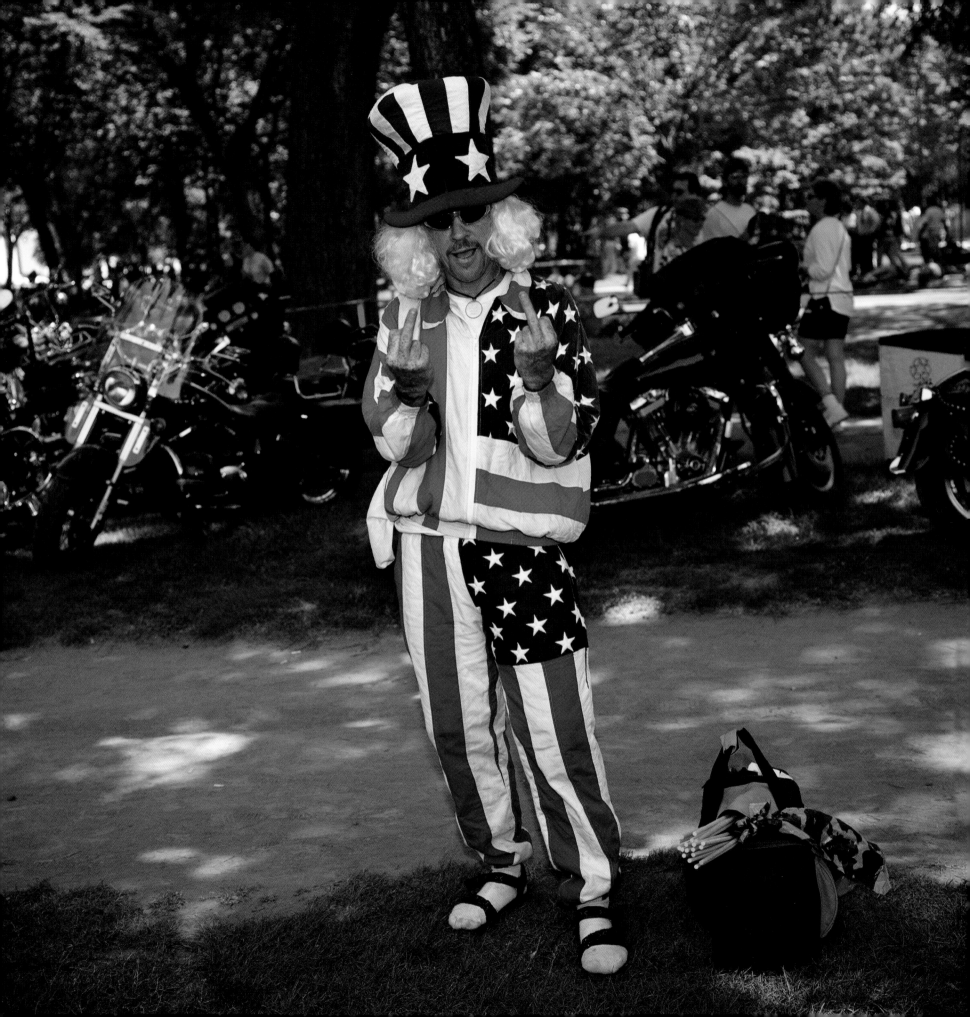

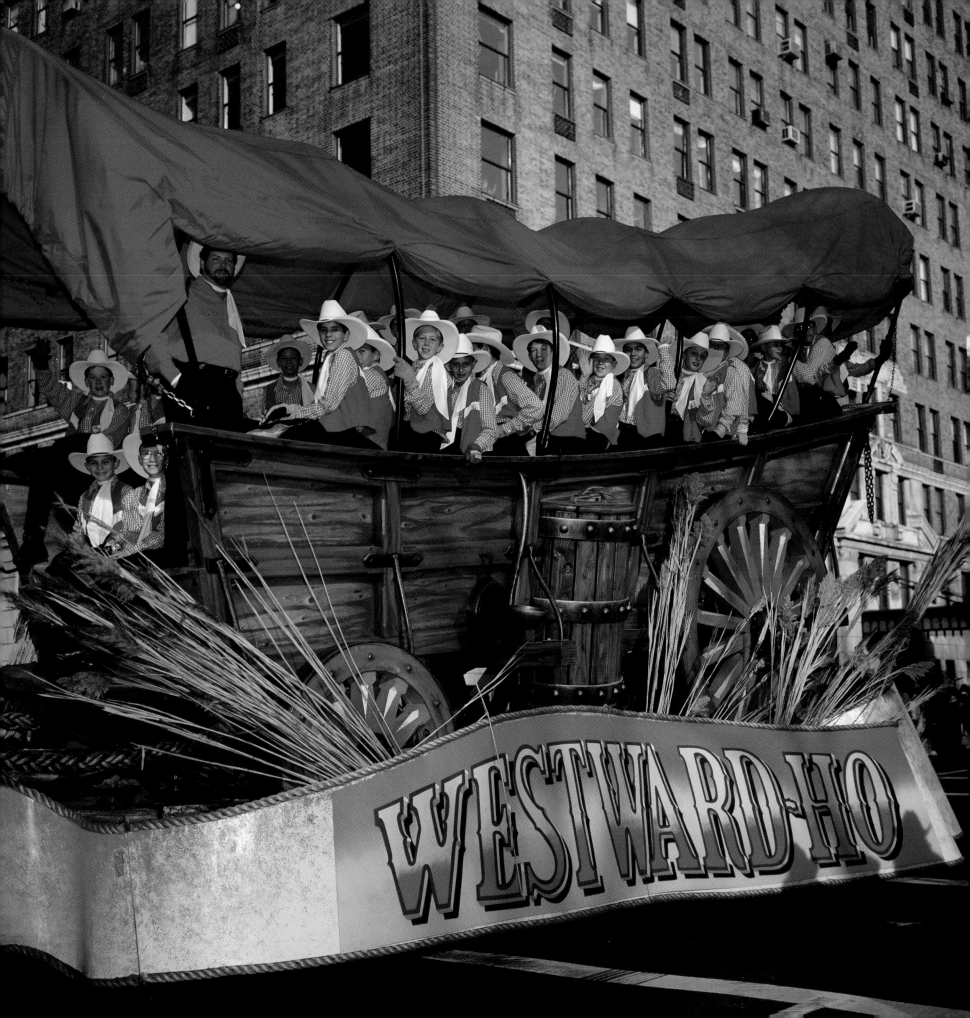

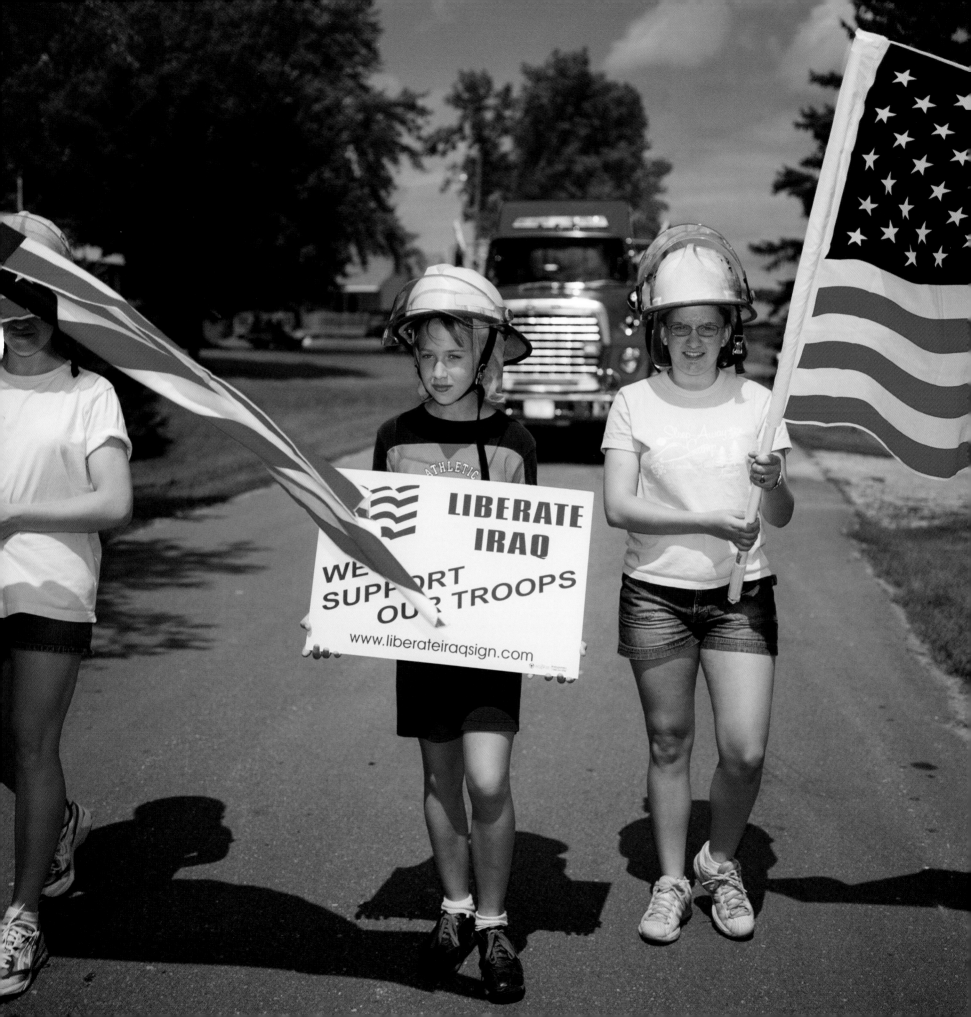

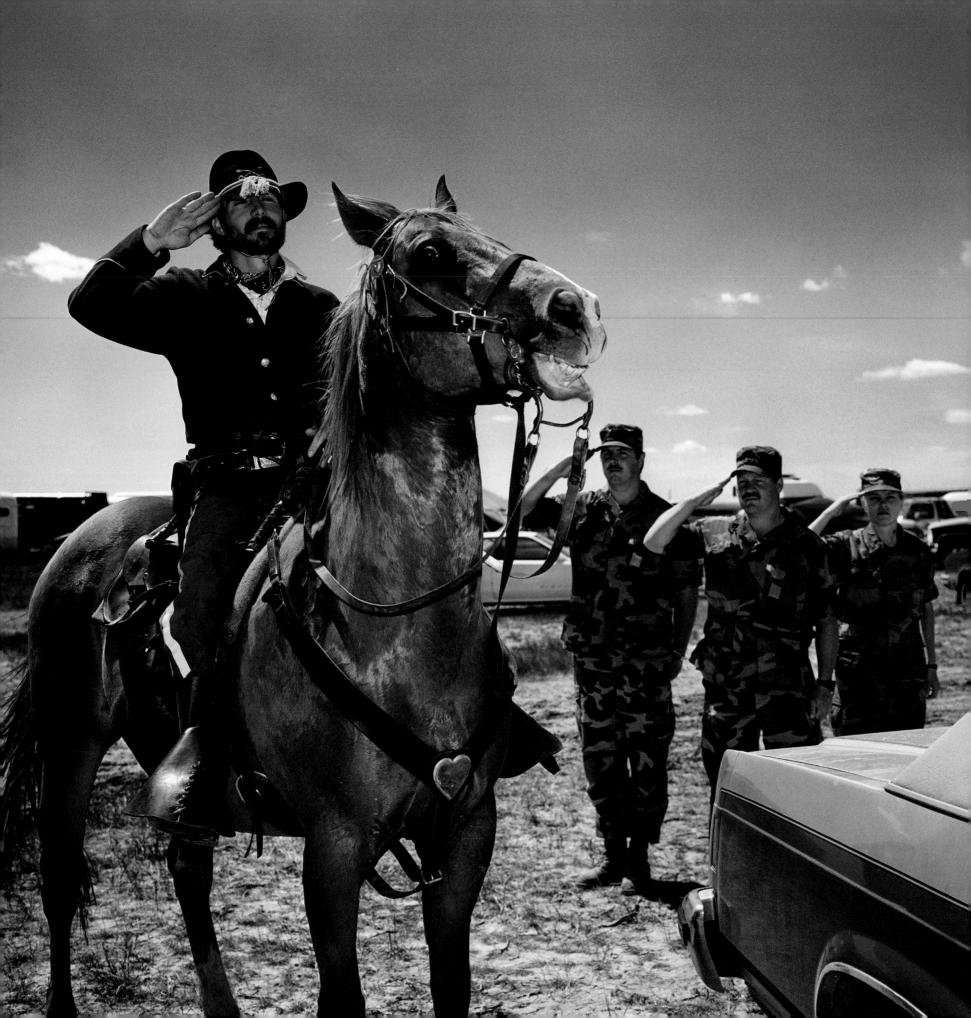

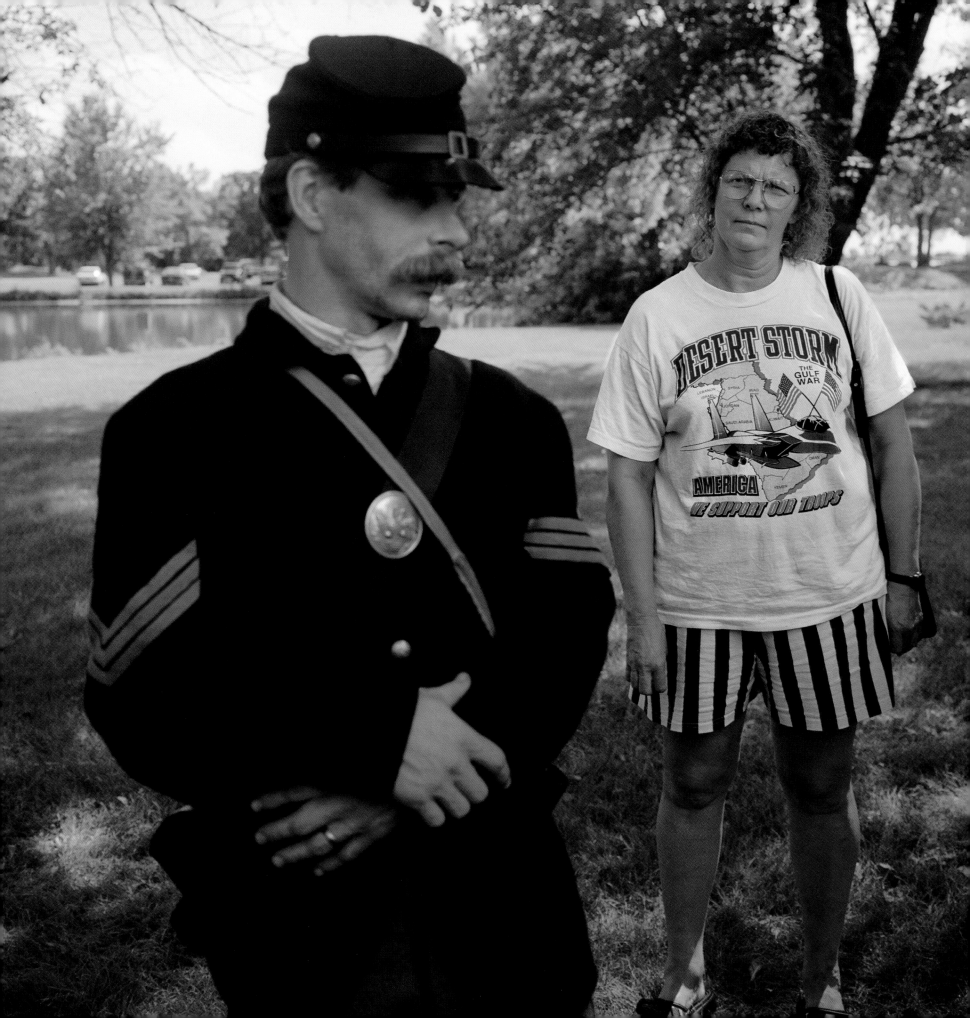

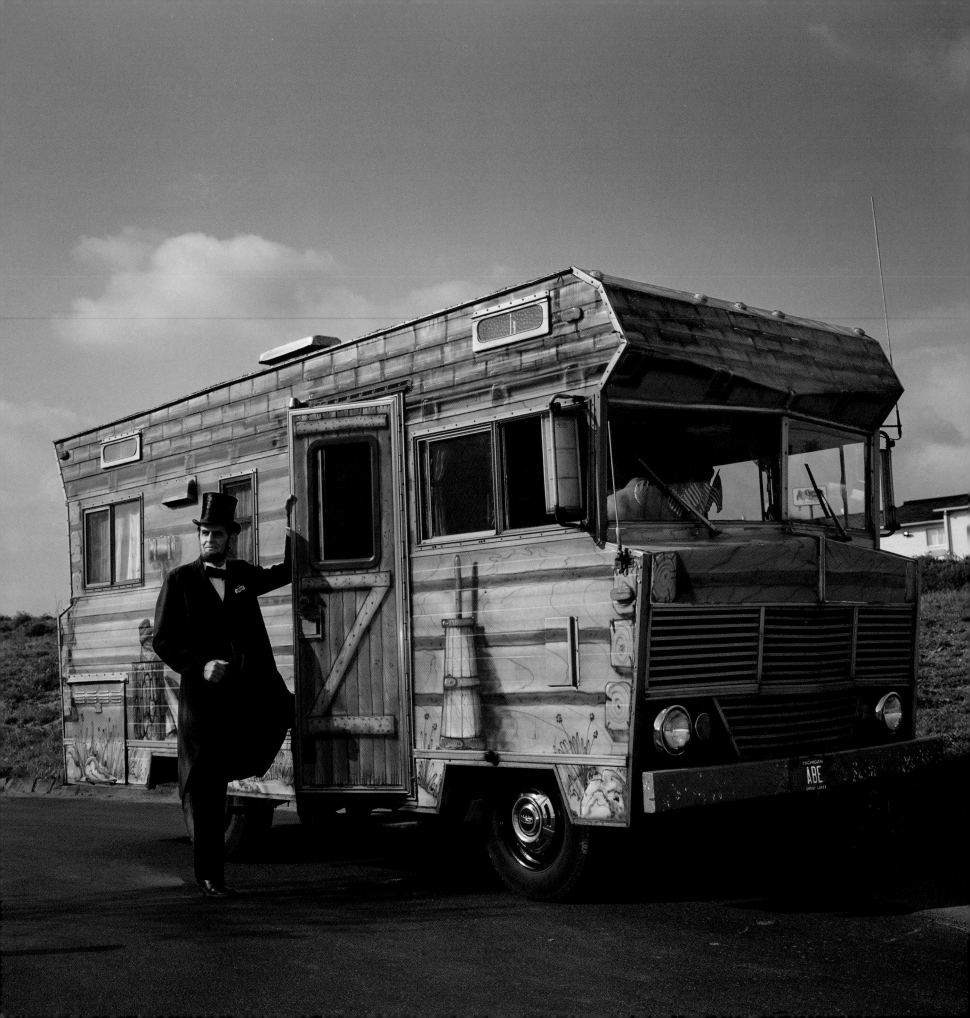

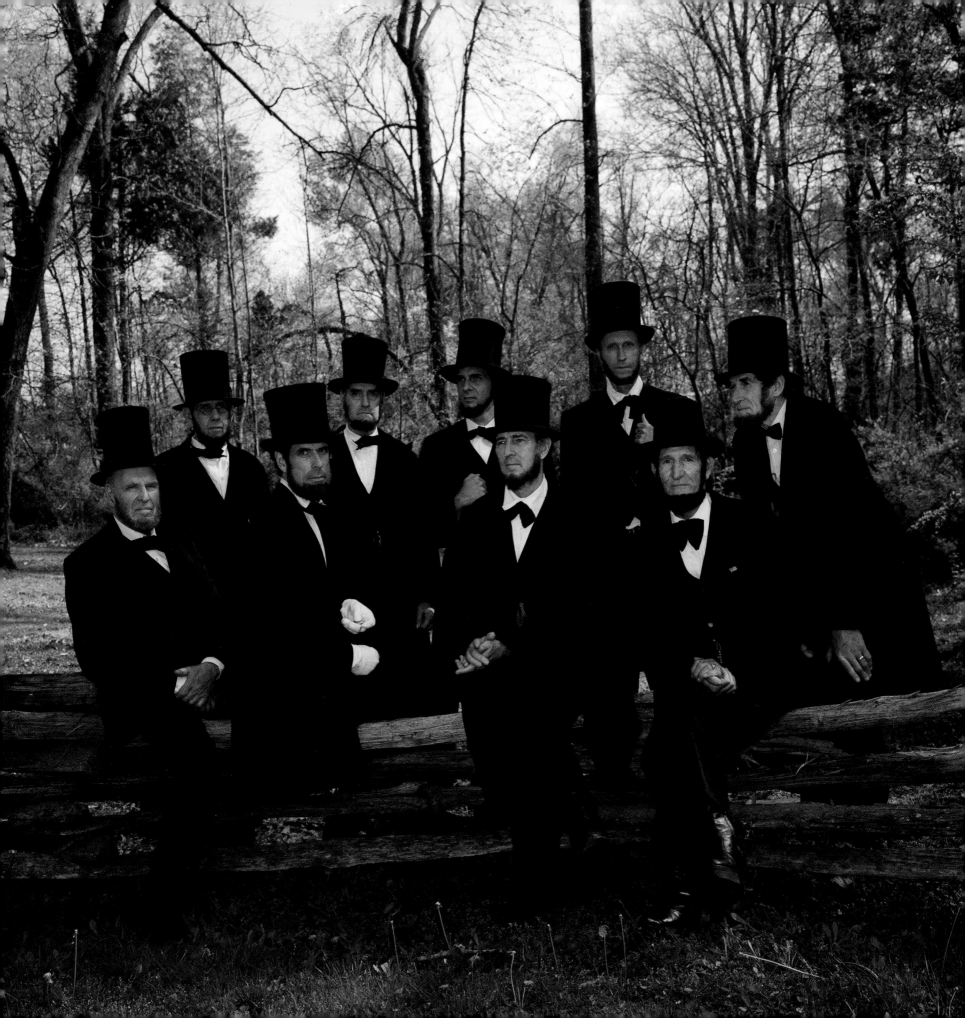

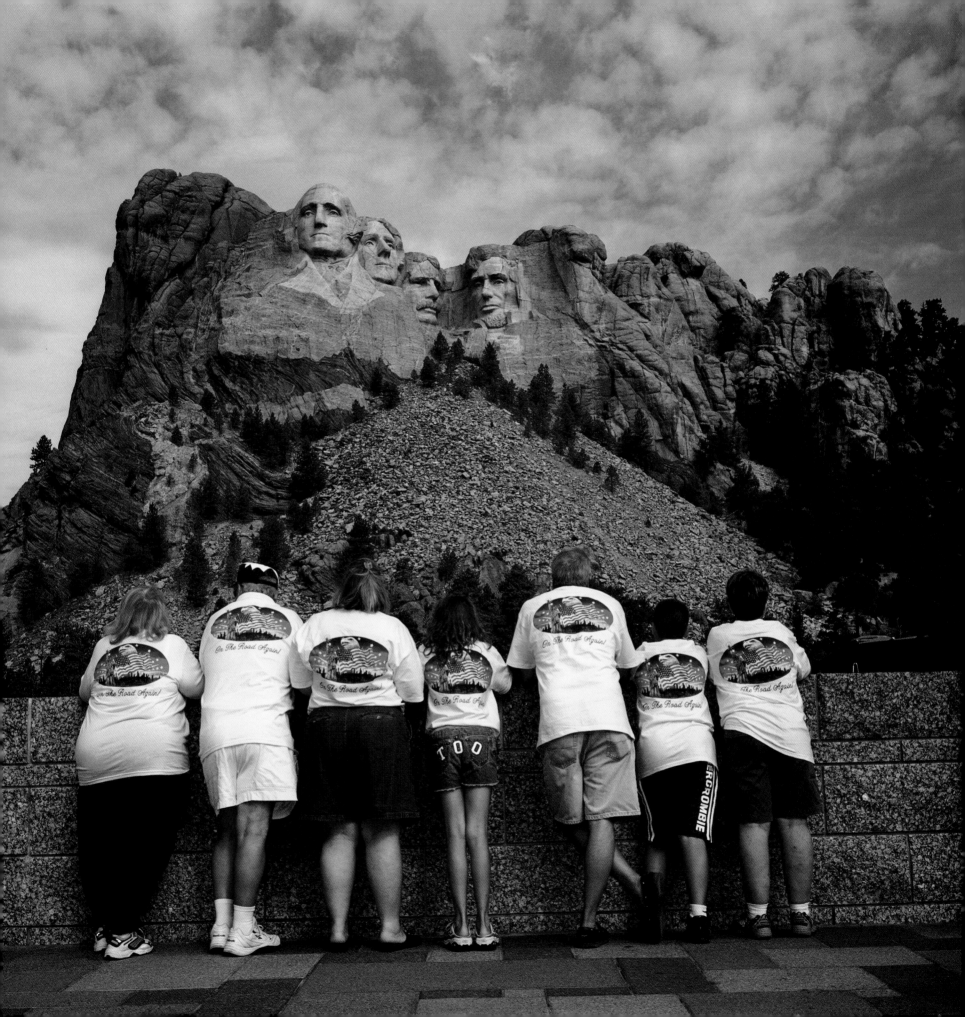

TOURING HISTORY WITH GRETA PRATT:

We have seen the past, American—and it is now!

A couple of years ago, I was asked to guide some foreign visitors on a trek into northern Minnesota in search of the headwaters of the mighty Mississippi. In fact, the source of the Mississippi River is one of nature's ironies. The huge, moving ocean of water that neatly bisects the continent, the quasi-mythical setting for Tom Sawyer's adventures and the lilting melody of "Ole Man River," begins in a puddle, a tiny creek that meanders southward out of little Lake Itasca, no bigger than a trickle. The sign announcing the fact that this is the sacred spot is bigger than the stream. But tourists love to pose under the sign, with one foot on each muddy bank, easily straddling the Father of Waters. Even geography—great rivers, mighty plains and the rest—are not quite as advertised, sometimes. Reality disappoints (or surprises). The places and spaces of the imagination are generally a lot better.

So, too, with history and time. On that same epochal trip, we paused along the way to take in the local attractions: a deep-rock coal mine, now defunct; a museum honoring the saga of long-distance bus transportation; an Indian-run casino; the cocktail lounge of a going-to-seed hotel with a revolving restaurant on the roof. And everywhere we stopped, there was Elvis. Elvis clips on a TV set. Pictures of Elvis Presley in his swivel-hipped prime. A wannabe Elvis on a motorcycle. Statues of Elvis. "Give us this day our daily Elvis," we chanted, every time we stopped for a Coke (another national icon in its own right).

Most often, at semiofficial points of interest, Elvis was a kind of historical marker, a sign that something happened just before or after Elvisdom. Maybe in classier venues, there might have been solemn, painted timelines, or a TV set showing Ike or LBJ or Walter Cronkite giving a speech. But where, exactly, in that imaginary realm called history is Ike, anyway? Or almost any other major figure of the last century, except Elvis? Elvis is rebellion, energy, youth—the time when those of us who drive the vans and stop to see the seedy tourist attractions were young. Or wish we had been. Elvis is our history. Our way back when. A bright (if vague) marker in time. An era, a feeling, a once upon a time. Out there on the highways of America, in those innocent days before 9/11, Elvis was everywhere.

Greta Pratt spotted a brace of nine Abe Lincolns alongside their log cabin Winnebago somewhere in Kentucky not long ago. Like the troupes of Elvis impersonators—black, Latino, female, juvenile—who show up at fairs and trade shows, the Abe Squad is funny. It is also disconcerting, though, because the multiple Lincolns point out two home truths. First, in America everybody is, or can be, Abe Lincoln. And second, Abe

Lincoln is, or might be, just about anywhere. Real time doesn't mean much to us in the end. We live in a perpetual present in which Abe and Elvis and Tweety Bird and Mickey Mouse—and old George Washington with funny teeth and the murderous George Armstrong Custer in his fancy duds—all coexist quite nicely. Back there.

Our is a dream world of shiny bright symbols and trademark history. It's a kind of show, a pageant. Every Christmas in the far reaches of suburban Philadelphia, good old George Washington crosses the Delaware River and dispatches the drunken Hessians. The cavalry always appears from behind a rise just in time to save the settlers. The South is forever gallant and the North is brave. And things turn out just fine, every time (unless, of course, you happen to be a Native American or a member of Pickett's doomed company). History is a pretty nice place, if a little predictable. Reenactments, theme parks, and history villages contrive to show us that yesterday was just like today, only more exciting—and the electrical outlets were hidden behind the old sap bucket.

There was a day when every schoolchild knew the old stories about Washington chopping down the cherry tree, about Lincoln reading by the light of the fireplace, and Ike agonizing over the D-Day landings in France. Moral lessons are not a big part of the curriculum these days. Nor is moral confusion, now replaced by a terrible certainty that we must always be right because we are Americans. The flag is everywhere, more ubiquitous than Elvis and a lot more specific, too. Elvis meant a society in which rebels were always welcome: the good Indians from the Saturday afternoon Westerns; the handsome, red-haired Tarleton twins from Gone With the Wind; the skinny lawyer who stood up to the crowd in John Ford's Young Mr. Lincoln. But the flag too often means that no rebels are welcome here.

Or is this just the Hollywood Old West all over again? Cowboys vs. Indians. Lawmen vs. outlaws. Ranchers vs. farmers. There's no _____ like a dead _____! Fill in the blanks and wave the red, white, and blue! Do we really believe in heroes anymore? The Lincolns? The Ikes? The old vets who march in the Fourth of July parade? What do those Cub Scouts really mean when they "pledge allegiance" and raise the flag?

Just outside Keystone, South Dakota, on a parapet overlooking Mount Rushmore, seven vacationers lean against the stone wall and contemplate the Big Heads. The world's biggest presidents: Washington, Jefferson, Teddy Roosevelt, Lincoln, as sculpted there, in an act that seems almost to defy the shaping hand of nature, by one Gutzon Borglum, beginning in 1927. Historians have squabbled ever since over why these Presidents. From time to time, some congressman trying to make hay with the electorate suggests an addition. FDR. Ronald Reagan. But so far, the Big Heads have remained more or less intact, despite the occasional rock slide, four presidents with a stake in the Great American West, which begins right here, where the frontier used to be. Jefferson sent Lewis and Clark to map the West. Washington spent his youth surveying it. Lincoln the Rail

Splitter embodied its values. And Theodore Roosevelt reclaimed his soul by cowboying in the Badlands. (Alfred Hitchcock made Cary Grant chase bad guys up the mountain on this very spot, too, for symbolic reasons.) A place for big dreams, big ideas, Big Cinemascope Heads.

And Big Butts. Americans have gone soft during the past generation, according to hysterical media reports. Soft, cushiony, and gigantic, as if to match the scale of the Big Heads. If Washington and his buddies stood up, a park ranger told me, they would each be about 465 feet tall. Mythic proportions, all right. The classic American tourist in the cartoon used to stand in front of the Colosseum in Rome and boast that the Houston Astrodome was a lot bigger. Now, the American is bigger, as if in order to be commensurate with all the bragging and dreaming, the ultimate fulfillment of the dream of perpetual abundance, we needed to be big, too. On every T-shirted back in Greta's picture is inscribed the same logo: "On the Road Again," the title of an old Willie Nelson song. Ironically, old Willie was and is the skinniest possible American. Hobos and pilgrims and wanderers like these have always been thin—emaciated by their own flame of longing and desire. Not these folks, except for the little girl, who hasn't grown into her birthright yet. The grownups have it all. RVs. Frozen pizza. Computers. And by the way, the vending machines just out of the picture at the right sell snacks and Cokes, if anybody's hungry.

Mount Rushmore is always having anniversaries, to pump up the volume of summer tourists. During the administration of G.H.W. Bush, the sitting president came to Keystone for one such weekend of hoopla, along with Rosemary Clooney and a cast of thousands, including lots of bikers bound for their annual rally in nearby Sturgis. Only a true believer would have tried to wiggle into the park during the ceremonies proper. But it made no difference if you went or didn't. Keystone, Sturgis, Wall: The Dakotas were a tale of sold-out rooms (we bunked in with the teenage son of a motel owner), empty Coke machines, $10 burgers, and warm six-packs to go. Huge bikers and scrawny little biker babes who looked like Willie Nelson's sisters. Gigantic truckers, stranded in the snarl of traffic. Big fat families on the move. Matching T-shirts. And an Elvis. I swear to God, a pudgy Elvis working the gift shops that peddled Black Hills gold and made-in-Taiwan Indian feather headdresses. And there we all were, abroil in the heat, jostling and joshing. O America! We are here. We are many. We are big. We are ignorant. But we love a parade, a Coke, a president, an Elvis, a carload of Abe Lincolns in tall hats. We are our own history. And it is now.

Karal Ann Marling

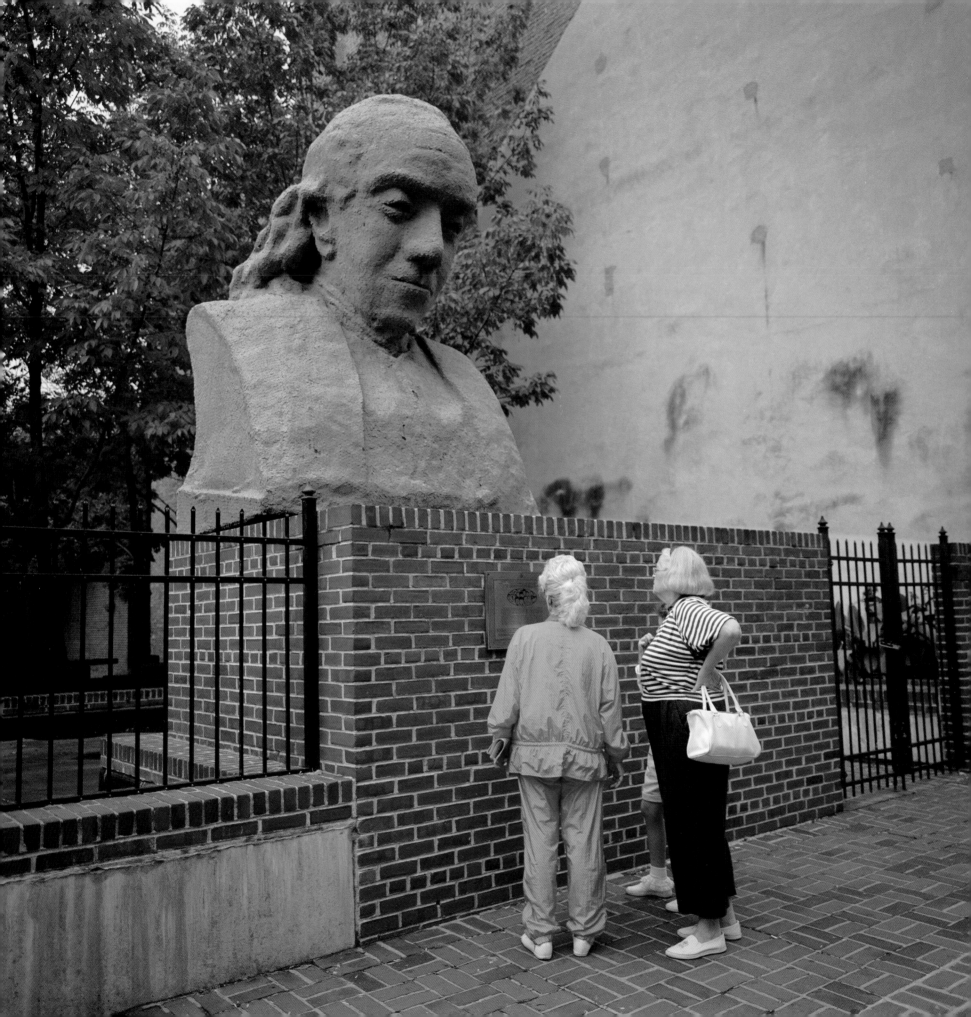

CAPTIONS

Ike, Gettysburg, Pennsylvania, 1991

Shoot-out at the Ok Corral, Tombstone, Arizona, 1994

Wanted Dead or Alive, Staten Island, New York, 2002

Howdy Podner, Deadwood, South Dakota, 1991

Astronaut with French Fries, Houston, Texas, 1997

Girl with Tweety Bird Balloon, Lexington, Massachusetts, 1997

Buffalo and Winnebago, Keystone, South Dakota, 1991

Wigwam Motel, Holbrook, Arizona, 1994

Kennedy Space Center Picnic, Cape Canaveral, Florida, 1992

Kennedy Space Center Gift Shop, Cape Canaveral, Florida, 1999

In Memory of T-Shirt, New York, New York, 2003

Lexington Lions, Lexington, Massachusetts, 1996

Thanksgiving at the Rainbow Room, New York, New York, 1995

The Chieftain Motel, Cooperstown, North Dakota, 1998

Fifth Grade Trip to Ellis Island, New York, New York, 2000

Mount Rushmore Soda Machine, Keystone, South Dakota, 2002

Presidents' Day in Kindergarten Class, Ringwood, New Jersey, 2000

Children Playing Civil War, Gettysburg, Pennsylvania, 1991

Little Patriot, Williamsburg, Virginia, 1991

Flag Day, New York, New York, 1993

Children with Confederate Flag, Fort Stevens, Oregon, 1993

Totem Pole Waits for Parade, Hardin, Montana, 1993

Native American Children Near the Little Bighorn, Hardin, Montana, 1993

KKK Display at the Great Blacks In Wax Museum, Baltimore, Maryland, 1996

Arrival of the Whites, Deadwood, South Dakota, 1991

Liberation Monument, Liberty State Park, New Jersey, 1997

United States Air Force Museum, Minot, North Dakota, 1991

Headless Statue on Fourth of July, Philadelphia, Pennsylvania, 1993

Turbaned Tourist and the Seventh Cavalry, Hardin, Montana, 1993

Custer Signs Autographs, Hardin, Montana, 1993

Women at the Pinkster Festival, Sleepy Hollow, New York, 1996

Mammy's Cupboard Restaurant, Natchez, Mississippi, 1997

Powwow Dancer, Rapid City, South Dakota, 1996

Man Eating a Turkey Leg, Orlando, Florida, 1992

Actors at a Juneteenth Celebration, Richmond, Texas, 1996

Waiter Arriving for a Confederate Ball, Richmond, Virginia, 1996

Boy with Flag over Face, Gettysburg, Pennsylvania, 1991

Patriotic Girls on the Fourth of July, Sturbridge, Massachusetts, 1991

Woman by Outhouse, Hardin, Montana, 1993

Frontier Town, North Hudson, New York, 1991

African Spirit at Masquerade Ball, Baltimore, Maryland, 1997

Black Panthers at Masquerade Ball, Baltimore, Maryland, 1997

Indian and Cowboy, Lusk, Wyoming, 1996

Family Buying White Bread, Lusk, Wyoming, 1996

Native American with Flag, Rapid City, South Dakota, 1996

Boy Dressed as Custer, Hardin, Montana, 1993

Soldier Reenactors at Presidential Inaugural Parade, Washington, DC, 1997

Vietnam Veteran on Memorial Day, Washington, DC, 1999

Lady Liberty at Madison Square Garden, New York, New York, 1998

Channel Two News, Monmouth, New Jersey, 1991

Washington Crossing the Delaware, Washington Crossing, Pennsylvania, 1991

Freddie Sez, Flag Day in New York, New York, 1993

Uncle Sam at Flash Dancers, New York, New York, 1992

Cowboy Kids, Wild West City, New Jersey, 1991

World's Largest Buffalo, Jamestown, North Dakota, 2002

Costumed Woman Pledging Allegiance, Hodgenville, Kentucky, 2000

Uncle Sam Flips the Bird, Washington, DC, 1999

Westward Ho, New York, New York, 1995

Liberate Iraq, Forado, Minnesota, 2003

Soldiers Salute, Hardin, Montana, 1993

Desert Storm T-Shirt, Mountain Lakes, Minnesota, 1995

Lincoln and Log Cabin RV, Hodgenville, Kentucky, 2000

Nine Lincolns, Hodgenville, Kentucky, 2000

Family at Mount Rushmore, Keystone, South Dakota, 2002

Women by Ben Franklin Head, Philadelphia, Pennsylvania, 1991

Colonial Woman with Camera, Alexandria, Virginia, 1997

Front Cover: Headless Statue on Fourth of July, Philadelphia, Pennsylvania, 1993

Back Cover: Nine Lincolns, Hodgenville, Kentucky, 2000

ACKNOWLEDGEMENTS

I am fortunate to have had the pleasurable company of my great friend Terri Gold and my sister Analisa Pratt on some of my many road trips. Thank you for coming along on the ride and providing some memorable off-road experiences as well.

Without the advice, insight, and support of many people this book would not have been possible. Special thanks to Avery Lozada and Donna Wingate at D.A.P. for showing my work to Gerhard Steidl, and thank you Gerhard for believing in this project. Also thanks to Julia Braun, Claas Möller and Inès Schumann.

This book is made more meaningful by the insightful writing of Rennard Strickland and Karal Ann Marling.

I am especially grateful to Jim Fossett for his perceptive editing and great sense of humor, and to Laurence Hauptman, David Krikun, Clif Meador, Patti Phillips, and Alan Trachtenberg, for discussing this work with me, and to Howard Zinn for introducing me to another version of history.

I want to thank everyone at the SUNY, New Paltz Visual Research Laboratory, especially Ann Lovett, Arthur Hoener, Francois Deschamps, Ann Galperin, Amy Papaelias, Jaanika Peerna, Hynek Alt, and Aleksandra Vajd.

Thank you also to Kathy Ryan, Paul Shambroom, Phil Block, Philippe Laumont, Candace Perich, Sara Krajewski, Anne Wilkes Tucker, Ted Hartwell, Grazia Neri, Sydney Jenkins, Nan Richardson, Tom Arndt, Alison Morley, Maren Levinson, Arthur Spiegelman, Evy Mages, Chris Pratt, and Sue Peterson.

I am grateful to my mom and dad, Beverly and Douglas Pratt, for their love and support.

Most of all, I want to thank my husband and fellow photographer, Mark Peterson, for his endless encouragement and unconditional support. Also my amazing children Axel and Rose: My life is blessed because you are in it.

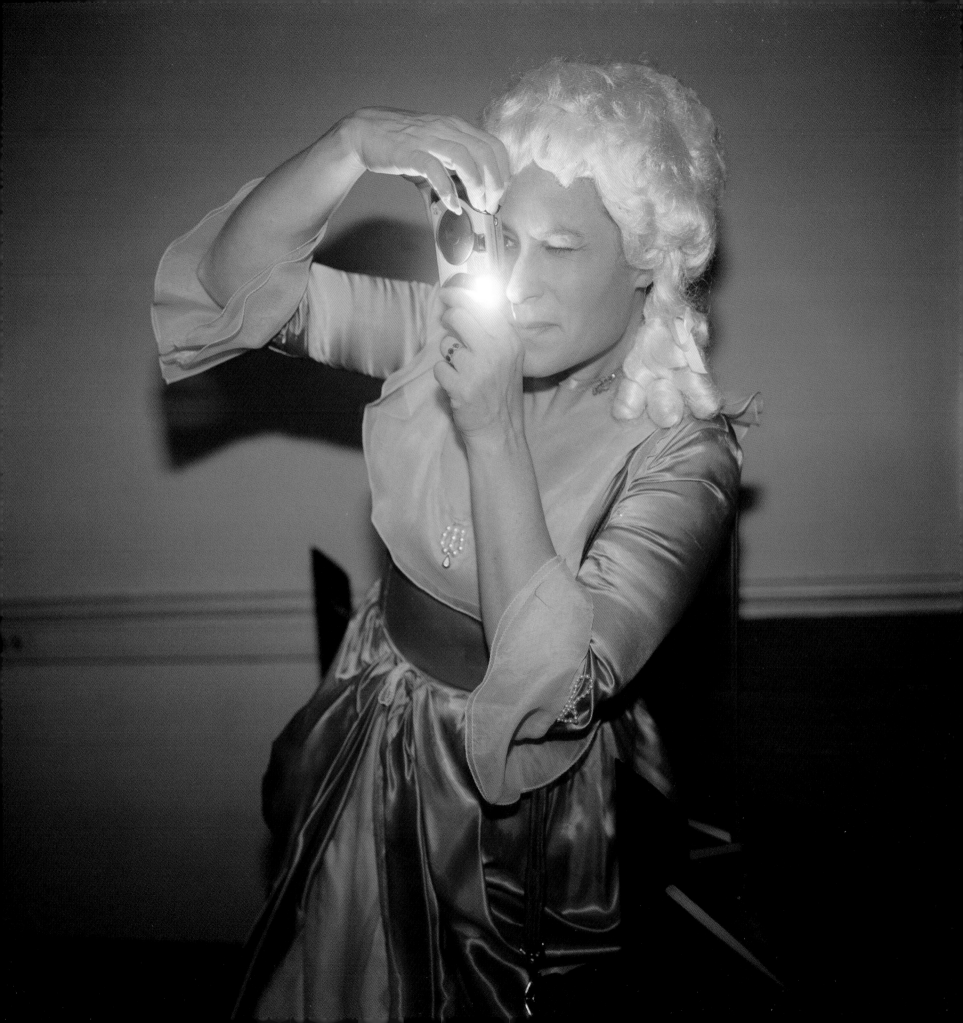

First edition 2005

Copyright © 2005 Greta Pratt for the photographs
Copyright © 2005 by the writers for the essays

Book design: Greta Pratt and Claas Möller
Printing and production: Steidl, Göttingen

STEIDL
Düstere Str. 4 / D–37073 Göttingen
Phone +49 551-49 60 60 / Fax +49 551-49 60 649
E-mail: mail@steidl.de / www.steidl.de

ISBN 3-86521-129-1
Printed in Germany